D0358426

Watercolour Workshop

EDINBURGH
LIBRARIES

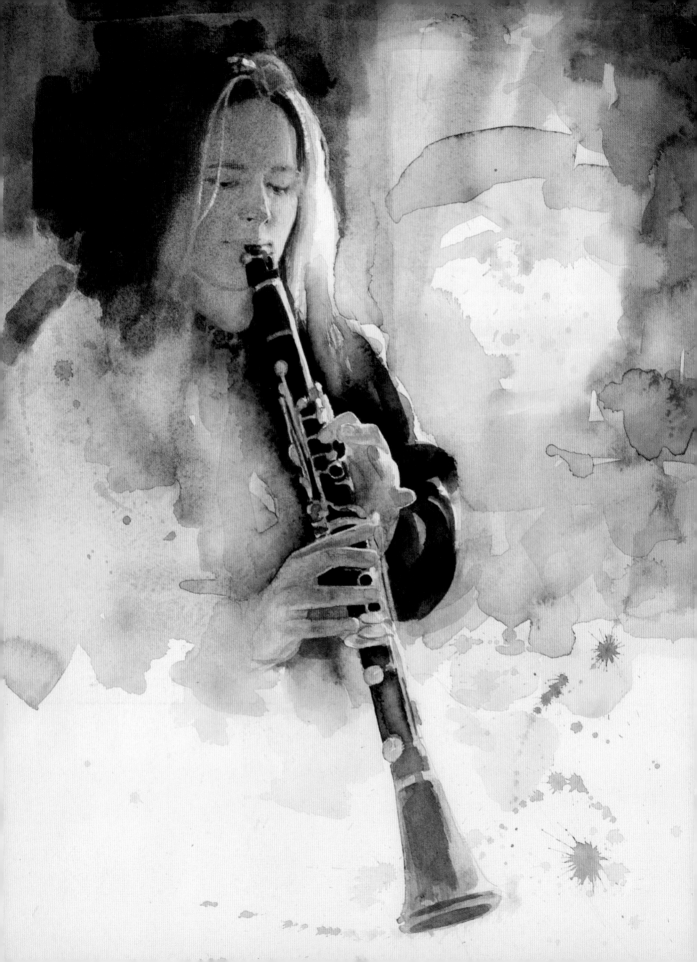

Watercolour Workshop

Glynis Barnes-Mellish

THE CITY OF EDINBURGH COUNCIL	
C0024397318	
Bertrams	28.09.06
ND2420	£9.99
BH	AR1

A Dorling Kindersley Book

LONDON, NEW YORK, MELBOURNE,
MUNICH, DELHI

Editor Kathryn Wilkinson
Project Art Editor Anna Plucinska
Senior Editor Angela Wilkes
DTP Designer Adam Walker

Managing Editor Julie Oughton
Managing Art Editor Heather McCarry
Production Controller Wendy Penn

Photography Andy Crawford

First published in Great Britain in 2006 by
Dorling Kindersley Limited
80 Strand, London WC2R 0RL
A Penguin Company

2 4 6 8 10 9 7 5 3 1

Copyright © Dorling Kindersley Limited 2005
All rights reserved. No part of this publication may be
reproduced, stored in a retrieval system, or transmitted
in any form or by any means, electronic, mechanical,
photocopying, recording, or otherwise, without the prior
written permission of the copyright owner.

A CIP catalogue record for this book
is available from the British Library.

ISBN-13: 978-1-4053-1119-9

ISBN-10: 1-4053-1119-3

Printed and bound in China by
Hung Hing Offset Printing Company Ltd

Discover more at
www.dk.com

Contents

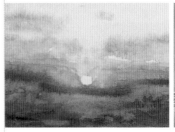

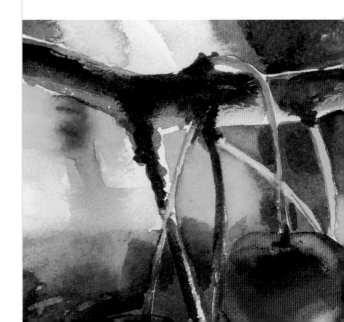

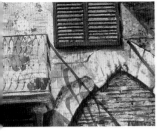
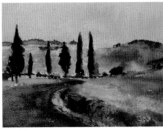
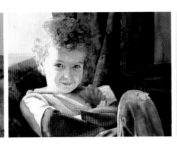

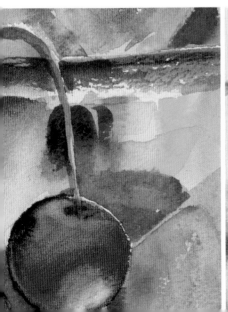
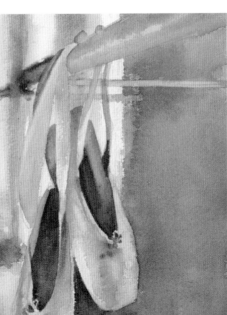
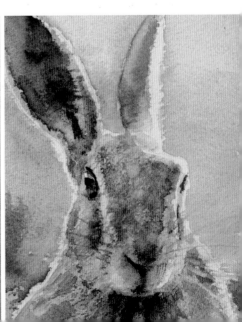

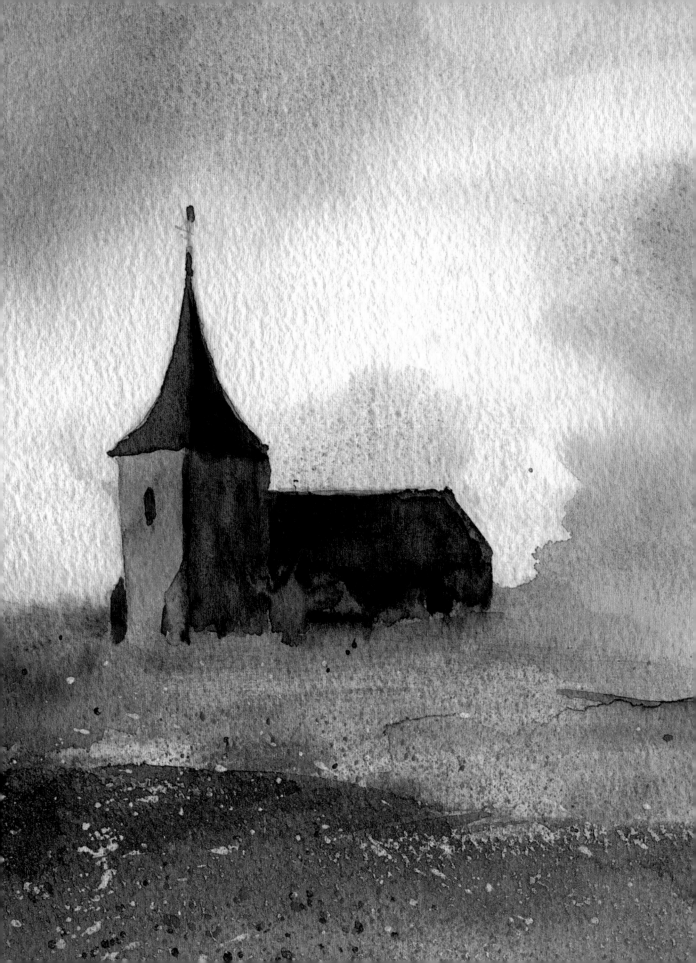

Introduction

Watercolour has a translucency unmatched by any other type of paint. The white paper shows through the brushstrokes, making the painting shine from within. It is this luminosity that enables you as a watercolourist to convey light uniquely: you can breathe life into portraits with glowing skin tones and capture the effects of scudding clouds, rain, or sunshine in skies and landscapes.

Clear, fresh, and colourful

When mixed with water, watercolour paints flow so freely that they continue to shift and change until completely dry. You can use this fluidity to create an expressive range of marks and textures, considered or spontaneous. For subjects such as skin, fruit, or glass,

which require a sensitive approach, you can use soft, blended strokes. At other times you may choose to work slowly, leaving each application of paint to dry before adding the next. Each layer shimmers through subsequent applications, creating gauzy veils of colour. When you paint "wet on dry" in this way, the results are controllable, allowing for precise and highly detailed work. Alternatively, you can think in colour and compose with the paint, drawing with broad, loose, personal strokes. When you work quickly and boldly, using strokes economically, the medium responds with a pleasing clarity. While many effects can be planned, sometimes watercolours react unpredictably and the results are unexpected. This spontaneity may at first seem daunting, but you can turn it to your advantage. If you exploit the effects of the accidental spread of the watercolour rather than creating every mark yourself, the medium will reward you with fresh and original paintings. There are many ways to work in watercolour and the right method is the one that suits you, which may change according to your mood, experience, and subject matter. Experimenting is the key to creating successful watercolour paintings in your own unique style.

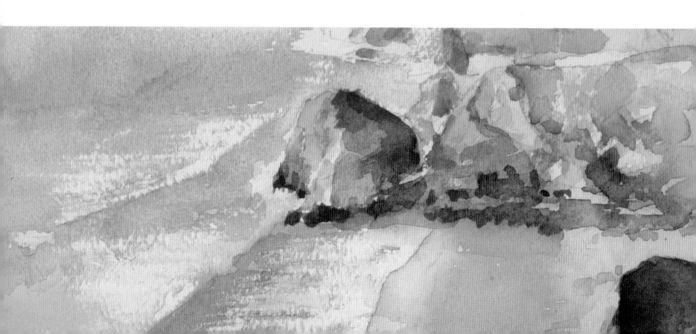

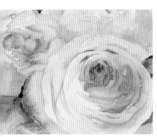

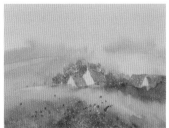

Learning about watercolour

The aim of this book is to provide a foundation for painting in watercolour, with advice on the key elements of picture-making and the techniques specific to this exciting medium. You can read the book and follow the exercises and projects as a beginners' course from start to finish, since each chapter builds on the previous one. Alternatively, you can dip in and study individual sections on subjects or techniques that particularly interest you. Either way, the hands-on approach means that you paint from the start and produce appealing images with just a few strokes. Because painting with watercolours and using colour go hand in hand, the four chapters that follow on from the materials and techniques section each introduce an increasingly sophisticated way of using colour, supported by a gallery of paintings by Old Masters and contemporary artists. The 12 projects make use of the basic techniques you have practised and give you the opportunity to learn new ones as you are led, step by step, to finished paintings on a range of subjects. As your confidence with watercolour grows, so will your appreciation of its radiance and versatility.

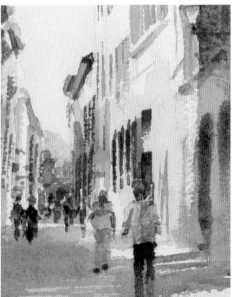
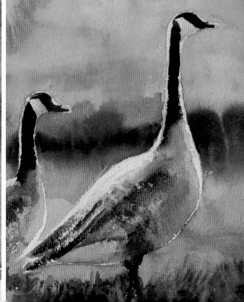

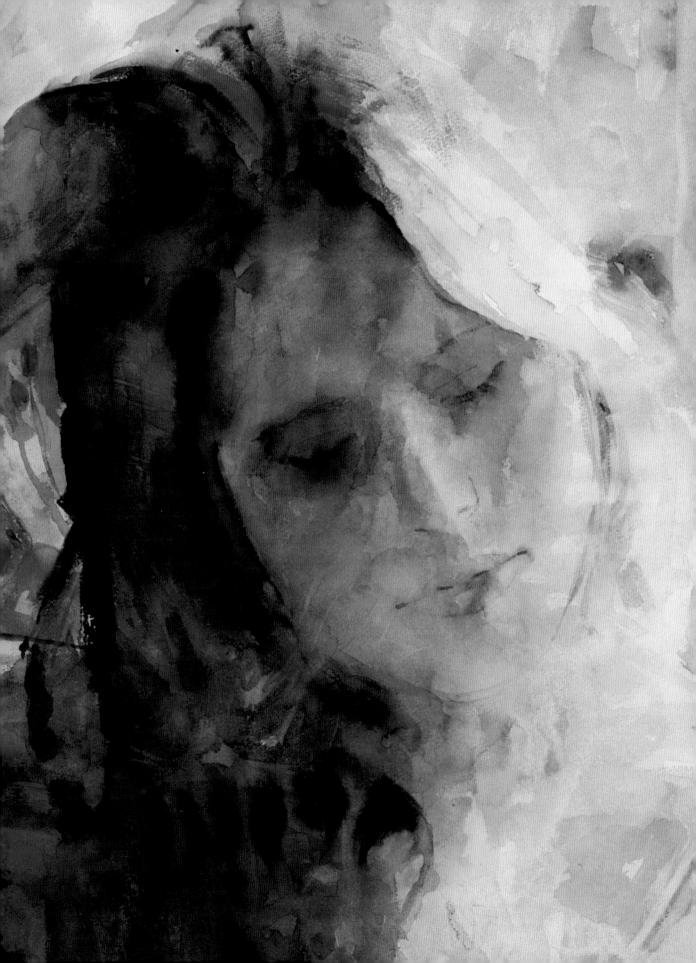

Materials and Techniques

Paint and other materials

You can buy watercolour paints in a vast array of colours, which can vary in form and quality. The two main forms of watercolour paint are tubes of fluid pigment and solid blocks called pans. "Artists' colours" are the highest quality watercolour paints.

These contain greater quantities of fine pigment than "Students' colours" and are more transparent so create more luminous paintings. It is a good idea to limit the range of colours that you buy to start off with and invest in the more expensive Artists' colours.

RECOMMENDED COLOURS

The ten paints below make up a good basic starter palette. You do not need to buy a larger selection because these paints can be successfully mixed together to create a wide range of colours.

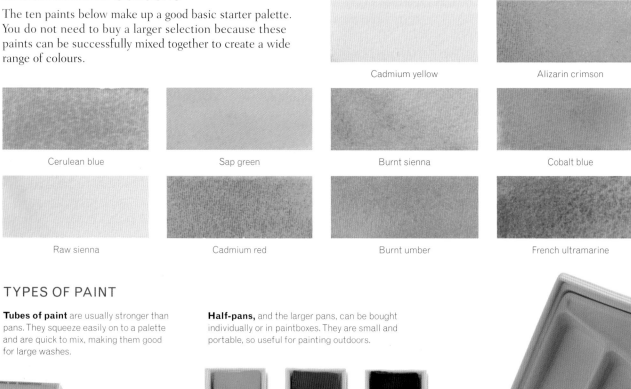

Cadmium yellow

Alizarin crimson

Cerulean blue

Sap green

Burnt sienna

Cobalt blue

Raw sienna

Cadmium red

Burnt umber

French ultramarine

TYPES OF PAINT

Tubes of paint are usually stronger than pans. They squeeze easily on to a palette and are quick to mix, making them good for large washes.

Half-pans, and the larger pans, can be bought individually or in paintboxes. They are small and portable, so useful for painting outdoors.

Paintboxes are a convenient way of storing and transporting half-pans or pans. The lids can be used as palettes.

OTHER MATERIALS

There is no need to buy a huge number of brushes to paint with; the range below will enable you to create a wide variety of effects. Apart from paints, paper, and brushes, keep kitchen towel to hand for mopping up spills and blotting out mistakes, and jars of water for mixing paints and cleaning brushes. You may also find some of the additional equipment below useful.

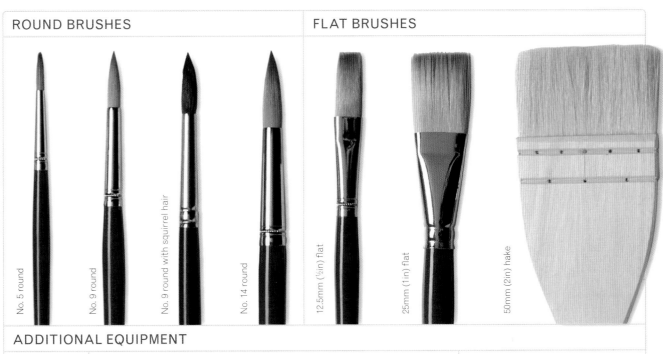

ROUND BRUSHES

No. 5 round

No. 9 round

No. 9 round with squirrel hair

No. 14 round

FLAT BRUSHES

12.5mm (½in) flat

25mm (1in) flat

50mm (2in) hake

ADDITIONAL EQUIPMENT

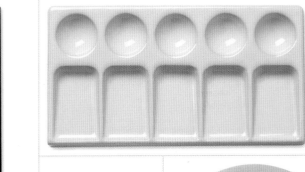

Well palettes have several compartments so that you can mix different colours without them running into each other.

Natural sponges are useful for mopping up excess paint and for creating textural effects.

Soft B pencils are useful for preliminary drawings.

Putty rubbers are soft and don't damage the surface of paper.

Masking tape is used to attach paper to a drawing board and give a painting a crisp edge.

Craft knives are for sharpening pencils and making highlights.

Masking fluid covers areas of paper to keep them white. Once it is removed, the paper can be painted as normal.

Paper

Paper is made from linen or cotton fibres or wood pulp. To make paper less absorbent and create a surface that can hold washes and brushstrokes, size is added. Lighter weight papers have less size so may need to be stretched first to prevent them buckling. You can buy paper with a variety of surfaces and in a range of weights, so it is best to buy single sheets of paper until you have decided which type suits you.

TYPES OF PAPER

There are three main types of paper surface: hot-pressed paper has a hard, smooth surface; cold-pressed or NOT paper has a slight texture; and rough paper has been allowed to dry without pressing. Paper weights are given in gsm (grammes per square metre) or lbs (pounds per ream). The choice ranges from light paper, which weighs 190gsm (90lb), to heavy 638gsm (300lb) paper.

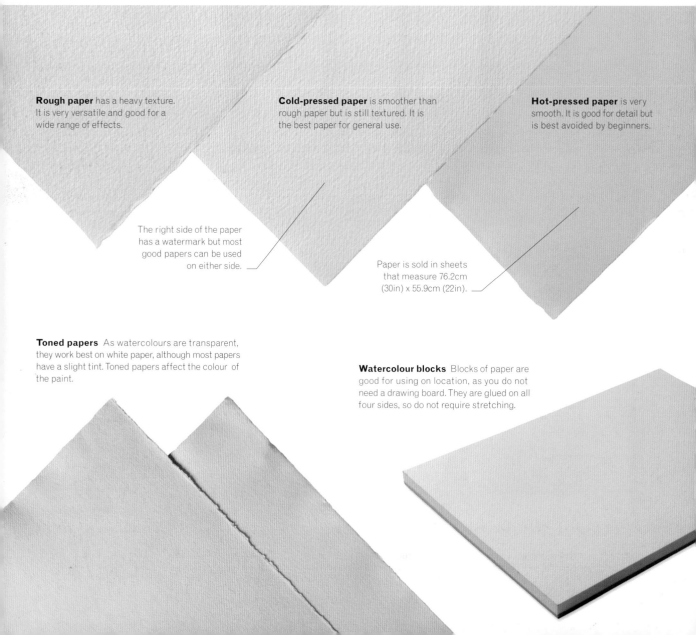

Rough paper has a heavy texture. It is very versatile and good for a wide range of effects.

Cold-pressed paper is smoother than rough paper but is still textured. It is the best paper for general use.

Hot-pressed paper is very smooth. It is good for detail but is best avoided by beginners.

The right side of the paper has a watermark but most good papers can be used on either side.

Paper is sold in sheets that measure 76.2cm (30in) x 55.9cm (22in).

Toned papers As watercolours are transparent, they work best on white paper, although most papers have a slight tint. Toned papers affect the colour of the paint.

Watercolour blocks Blocks of paper are good for using on location, as you do not need a drawing board. They are glued on all four sides, so do not require stretching.

PAINT ON PAPER

The type of paper you use has a marked effect on a painting. These three sunset paintings were all created using the same techniques, but were painted on the three different types of paper: hot-pressed, cold-pressed, and rough. As a result, the finished paintings look quite different from each other.

The washes have a hard edge.

Hot-pressed paper Washes are difficult to control on this paper and tend to dry with hard edges on the top of the slippery surface. This paper is better for a more linear subject.

Cold-pressed paper This is the easiest paper to use as the surface is good for broad, even washes. This type of paper is also suitable for paintings with fine detail and brushwork.

Even gradation and smooth marks.

Rough paper This paper can be quite difficult to use but reacts well to a bold approach. Washes are often broken by the paper's surface, which is useful when a textured effect is desired.

The wash breaks up on the pitted surface.

STRETCHING PAPER

Lay the paper, right side up, on a strong wooden board. Squeeze clean water from a sponge on to the paper so that it is thoroughly wet. Tip the board to let any excess water run off.

Stick each side of the paper down with damp gummed tape, overlapping it at the corners. Smooth the tape with a sponge. Let the paper dry naturally so it becomes flat. Keep the paper on the board until your painting is finished.

Brushes

Traditional watercolour brushes are made from soft hair and those made from sable are considered the best. Sable brushes are expensive, however, so when buying a first set of brushes look for synthetic and synthetic/sable blends, which have been developed to mimic pure sable. Whatever a brush is made from, it should point well and hold its shape, be able to hold a generous amount of paint, and be supple and springy.

ROUNDS AND FLATS

Round brushes are conical and can be shaped into a fine point. They are numbered: the larger the brush, the higher its number. Flat brushes are wide and have straight ends. Their size is given by a metric or imperial measurement. Use the rounds and flats in the recommended brush selection (*see p.13*) to enable you to create a wide range of strokes from fine lines to broad washes, as below.

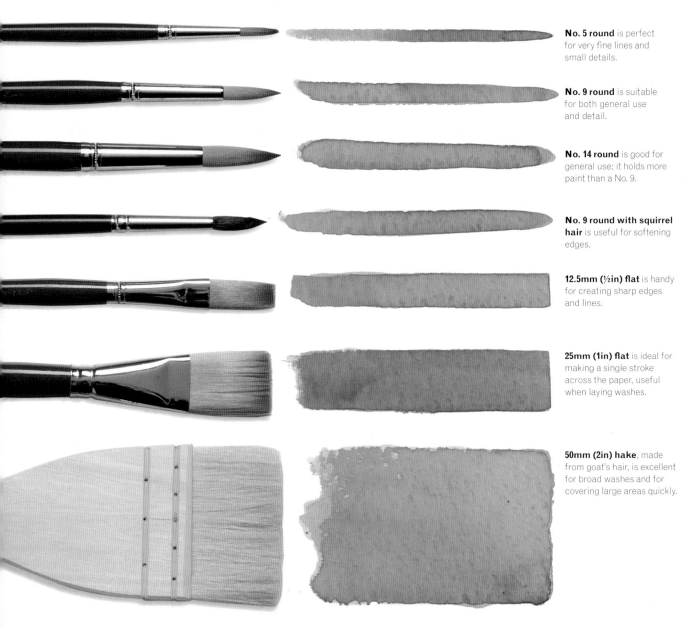

No. 5 round is perfect for very fine lines and small details.

No. 9 round is suitable for both general use and detail.

No. 14 round is good for general use; it holds more paint than a No. 9.

No. 9 round with squirrel hair is useful for softening edges.

12.5mm (½in) flat is handy for creating sharp edges and lines.

25mm (1in) flat is ideal for making a single stroke across the paper, useful when laying washes.

50mm (2in) hake, made from goat's hair, is excellent for broad washes and for covering large areas quickly.

BRUSHSTROKES

Watercolour brushstrokes should be smooth and flowing. Practise relaxing your hand and wrist so that you can make continuous strokes, letting the brush do the work. Try using the brush at different angles and speeds. All the brushstrokes below were made with a No. 14. It is a good idea to use a large brush for as long as possible in your paintings to avoid creating fussy brushmarks.

Upright brush

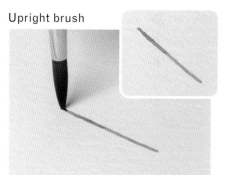

To make the thinnest possible line, hold the brush upright and only use the point.

Slanting brush

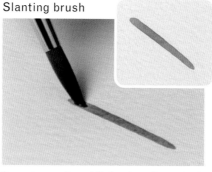

To create a medium-width line, lower the angle of the brush to use the centre of the hairs.

Low brush

To produce the widest possible mark, press down so that you are using the full width of the brush.

Varying strokes

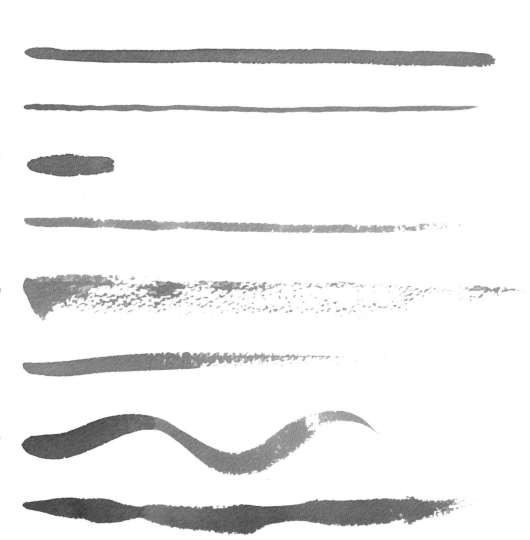

To create a long, solid stroke, move the brush slowly over the paper, letting the paint flow.

To make a fine, continuous line, hold the brush upright and just use the tip.

To make a petal-like mark, press the whole shape of the hairs down on to the paper.

To gradually lighten a mark, slowly lift off the brush as you move across the paper.

To create a broken, textured effect, drag the side of the brush quickly over the paper.

To make an expressive mark, speed up. Fast strokes are often straighter than slow ones.

To produce an undulating stroke, twist the brush rhythmically as you draw it across the paper.

To create this pattern, vary the pressure of your stroke as you cross the paper.

Brushstrokes

Try holding your brushes at different angles and varying the speed and pressure of your brushstrokes to create a variety of marks, as below. This will improve your brush control so that you become more relaxed and confident when painting. Trying out different brushstrokes will also help you to discover the range of effects you can make using round or flat brushes.

VISUAL EFFECTS

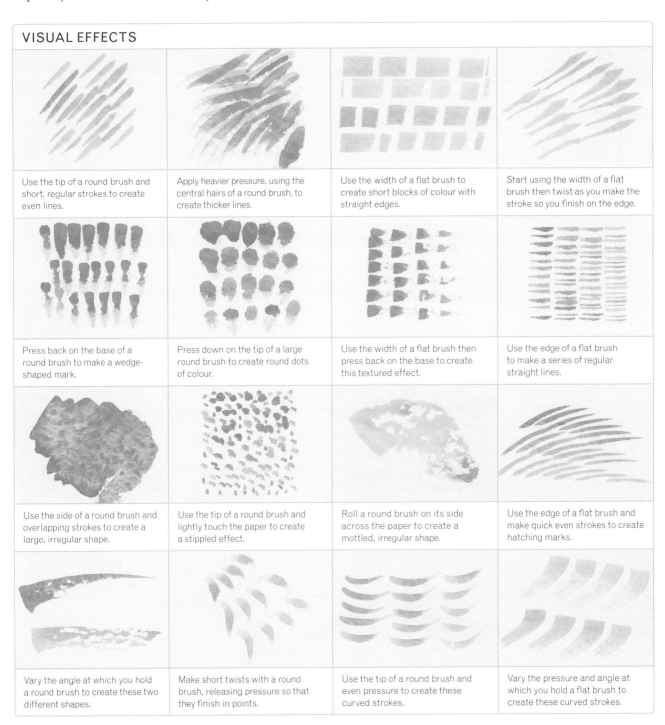

Use the tip of a round brush and short, regular strokes to create even lines.

Apply heavier pressure, using the central hairs of a round brush, to create thicker lines.

Use the width of a flat brush to create short blocks of colour with straight edges.

Start using the width of a flat brush then twist as you make the stroke so you finish on the edge.

Press back on the base of a round brush to make a wedge-shaped mark.

Press down on the tip of a large round brush to create round dots of colour.

Use the width of a flat brush then press back on the base to create this textured effect.

Use the edge of a flat brush to make a series of regular straight lines.

Use the side of a round brush and overlapping strokes to create a large, irregular shape.

Use the tip of a round brush and lightly touch the paper to create a stippled effect.

Roll a round brush on its side across the paper to create a mottled, irregular shape.

Use the edge of a flat brush and make quick even strokes to create hatching marks.

Vary the angle at which you hold a round brush to create these two different shapes.

Make short twists with a round brush, releasing pressure so that they finish in points.

Use the tip of a round brush and even pressure to create these curved strokes.

Vary the pressure and angle at which you hold a flat brush to create these curved strokes.

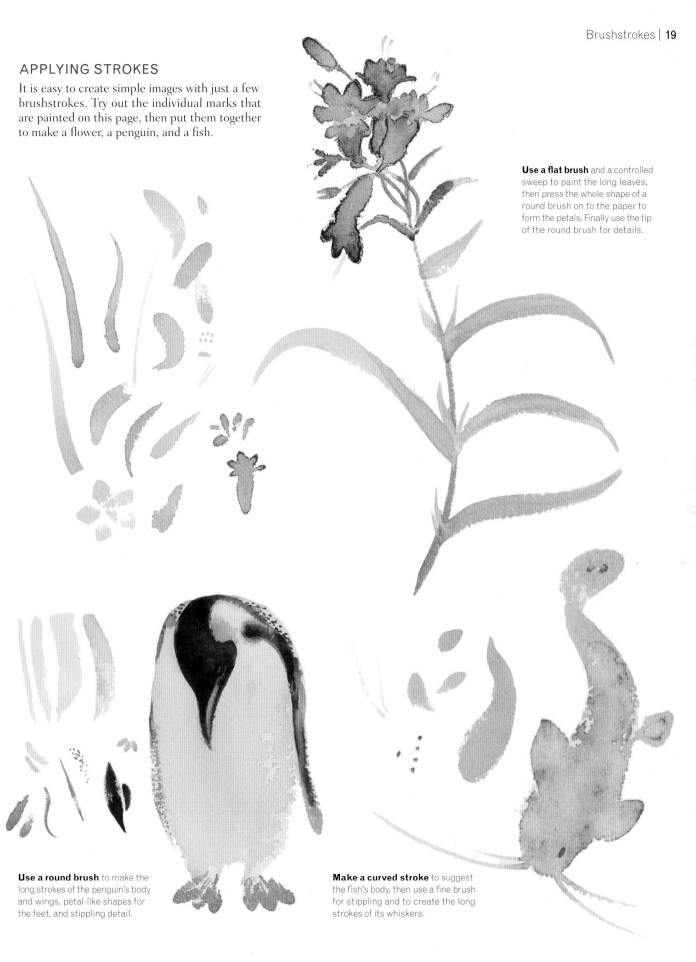

APPLYING STROKES

It is easy to create simple images with just a few brushstrokes. Try out the individual marks that are painted on this page, then put them together to make a flower, a penguin, and a fish.

Use a flat brush and a controlled sweep to paint the long leaves, then press the whole shape of a round brush on to the paper to form the petals. Finally use the tip of the round brush for details.

Use a round brush to make the long strokes of the penguin's body and wings, petal-like shapes for the feet, and stippling detail.

Make a curved stroke to suggest the fish's body, then use a fine brush for stippling and to create the long strokes of its whiskers.

Colour wheel

The colour wheel is a classic device that shows how the six main colours – red, purple, blue, orange, green, and yellow – relate to one another. The colour wheel contains the three primary colours and three secondary colours. Primary colours – red, yellow, and blue – cannot be mixed from any other colours. Secondary colours – orange, purple, and green – are mixed from two primary colours. The colours between the primary and secondary colours on the wheel are known as intermediate colours.

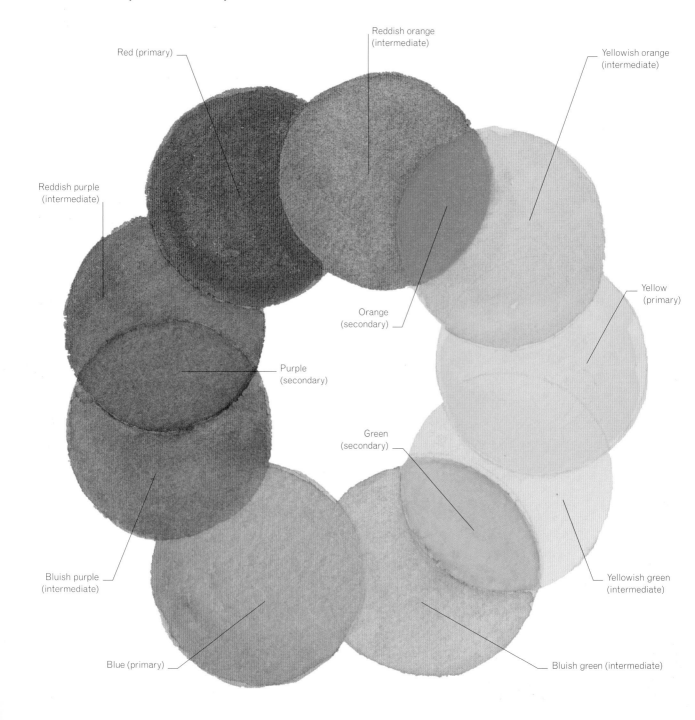

Red (primary)

Reddish orange (intermediate)

Yellowish orange (intermediate)

Reddish purple (intermediate)

Orange (secondary)

Yellow (primary)

Purple (secondary)

Green (secondary)

Bluish purple (intermediate)

Yellowish green (intermediate)

Blue (primary)

Bluish green (intermediate)

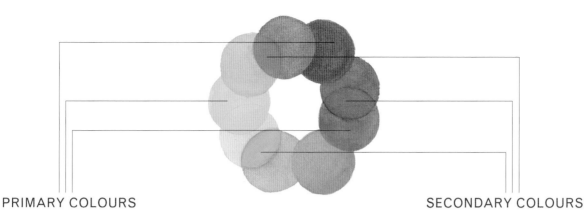

PRIMARY COLOURS

SECONDARY COLOURS

Red is one of the strongest hues and can easily overpower other colours.

Green is made from yellow and blue, so it neither appears to dominate or recede.

Yellow is the lightest tone, so appears to recede when placed next to other colours.

Purple is made from red and blue, so is strong but doesn't overpower other colours.

Blue is a very dominant colour and will not be overpowered.

Orange is made from red and yellow, so will lighten any colour it is mixed with.

Colour mixing

It is easy to mix watercolour paints to make new colours, both in a palette and on paper. The recommended basic palette of ten colours (*see p.12 and below*) includes the three primary colours, green, and browns, so you will be able to mix a wide range of colours. There are several shades of some colours; for example, there are two reds: cadmium red and the bluer alizarin crimson. The different shades of a colour react differently when mixed with other colours, increasing the range of colours you can create.

LIGHTENING COLOURS

By varying the amount of water you add to paint you can create a range of different shades from light to dark. If you want the paint to retain its translucency you should always make colours lighter by adding water rather than white paint, which makes colours opaque.

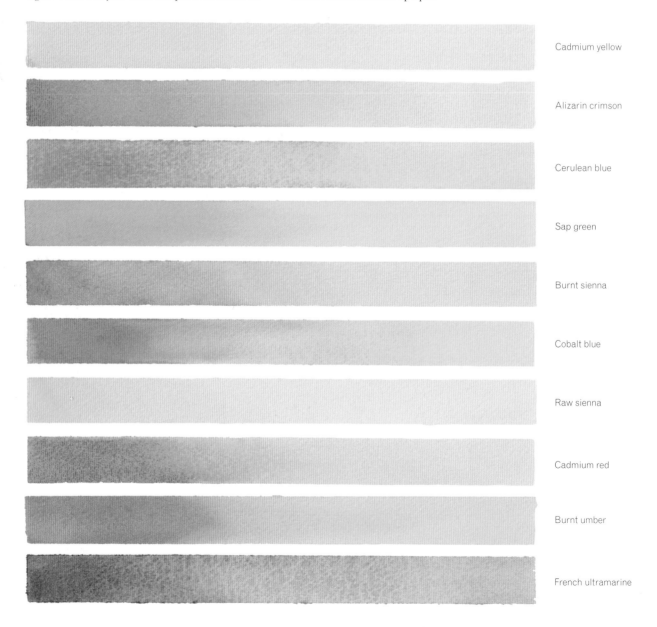

Cadmium yellow

Alizarin crimson

Cerulean blue

Sap green

Burnt sienna

Cobalt blue

Raw sienna

Cadmium red

Burnt umber

French ultramarine

MIXING COLOURS ON A PALETTE

Squeeze a small amount of paint from a tube on to your palette. Dip a brush into a jar of clean water then mix the water with the paint. Add more water until you have the colour you want.

Rinse your brush after mixing each new colour and keep the water in your mixing jar clean. To blend two colours, mix the dominant colour with water, then gradually add the second colour.

Watercolours look lighter when dry, so it is a good idea to test colours on a spare piece of paper, or around the edge of your colour test sheet (see p.37), before using them in a painting.

Make sure the dish or palette you are using has room to dissolve the pigment in a smooth puddle.

Use a white palette or dish, or a glass plate with white paper underneath, so you can see the colour you are mixing.

MIXING COLOURS ON PAPER

Mix two different colours with water in separate wells in your palette. Paint the first colour on to your paper with a clean brush. While this is still wet, add the second colour and it will mix on the paper to create a new colour. Sometimes when you mix two colours they will look grainy. This granulation occurs when the paints mixed have different weight pigments from each other. Try mixing colours to see which ones granulate. The effect is good for creating textures.

GRANULATION

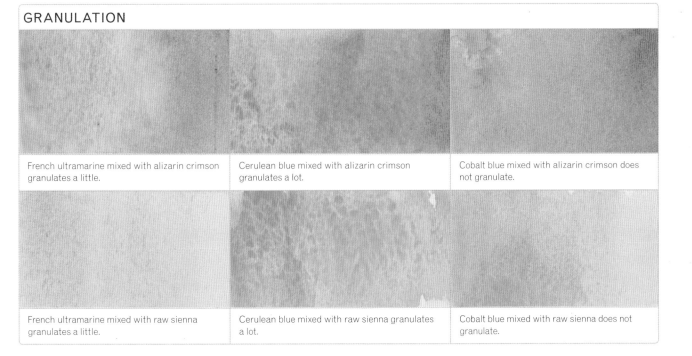

French ultramarine mixed with alizarin crimson granulates a little.

Cerulean blue mixed with alizarin crimson granulates a lot.

Cobalt blue mixed with alizarin crimson does not granulate.

French ultramarine mixed with raw sienna granulates a little.

Cerulean blue mixed with raw sienna granulates a lot.

Cobalt blue mixed with raw sienna does not granulate.

Colour blends

Practise mixing the ten colours in your basic palette to see how many new colours you can make. Try mixing combinations of two and three colours: don't use more than three colours as the end result will be muddy. It is a good idea to mix the paints on paper and label the colour swatches that you create, as below, so that you have a record of which colours mix together well.

MIXING TWO COLOURS

As you experiment with your paints you will see that some colours mix together more successfully than others. For example, French ultramarine mixed with alizarin crimson produces a pleasing warm mauve but if you use cadmium red instead of alizarin crimson you get a muddy purple. Here you can see examples of some of the best mixes that can be made from your basic palette.

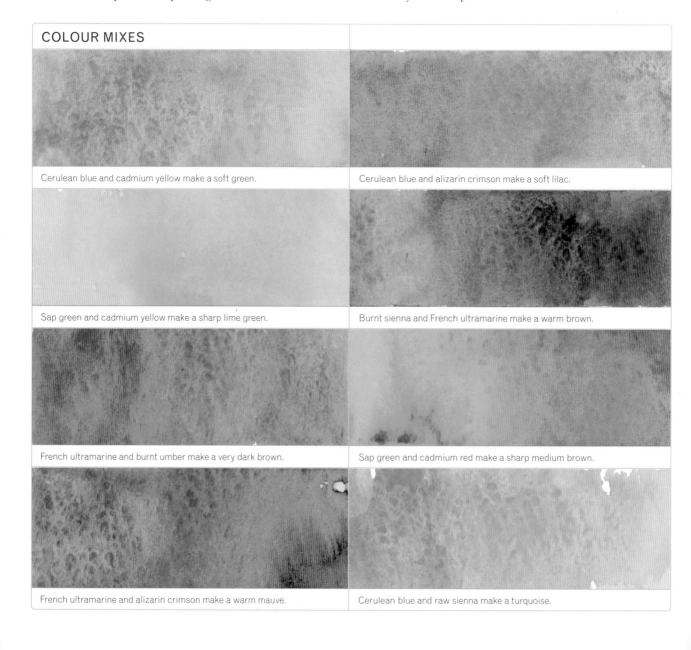

COLOUR MIXES

Cerulean blue and cadmium yellow make a soft green.

Cerulean blue and alizarin crimson make a soft lilac.

Sap green and cadmium yellow make a sharp lime green.

Burnt sienna and French ultramarine make a warm brown.

French ultramarine and burnt umber make a very dark brown.

Sap green and cadmium red make a sharp medium brown.

French ultramarine and alizarin crimson make a warm mauve.

Cerulean blue and raw sienna make a turquoise.

BLACKS AND BROWNS

There is no need to buy black watercolour paint, as you can make dark brown and black by mixing red, blue, and yellow. By using different shades of the primary colours you can make a range of dark colours.

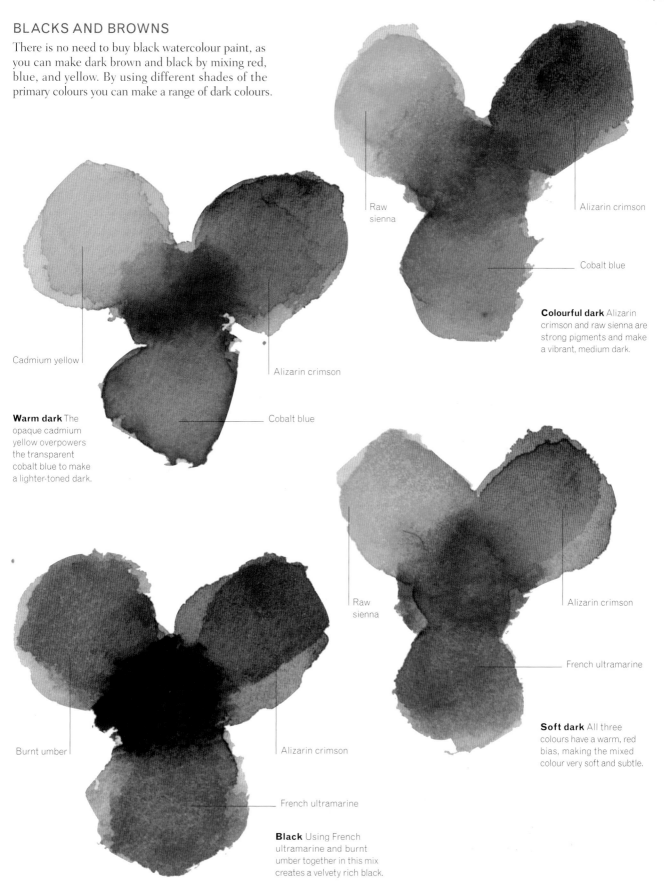

Raw sienna

Alizarin crimson

Cobalt blue

Colourful dark Alizarin crimson and raw sienna are strong pigments and make a vibrant, medium dark.

Cadmium yellow

Alizarin crimson

Cobalt blue

Warm dark The opaque cadmium yellow overpowers the transparent cobalt blue to make a lighter-toned dark.

Raw sienna

Alizarin crimson

French ultramarine

Soft dark All three colours have a warm, red bias, making the mixed colour very soft and subtle.

Burnt umber

Alizarin crimson

French ultramarine

Black Using French ultramarine and burnt umber together in this mix creates a velvety rich black.

Useful colour mixes

Some colours look better if you make them by mixing your paints rather than attempting to buy a tube or pan of the colour. Greens are often the colour painters have most trouble with but you can mix them very successfully. Skin colours may also seem difficult but you can make a wide range of realistic skin tones for any skin colour with mixes of just four colours from your basic palette.

MIXING GREENS

The range of greens that appears in the natural world is vast. However, there are few sources of green pigment and many of the manufactured green paints that you can buy are strong and lack the subtlety of natural greens. To expand your range of greens, mix bought greens with blue or yellow, or create your own by mixing blue and yellow or blue and orange.

GREEN VARIATIONS

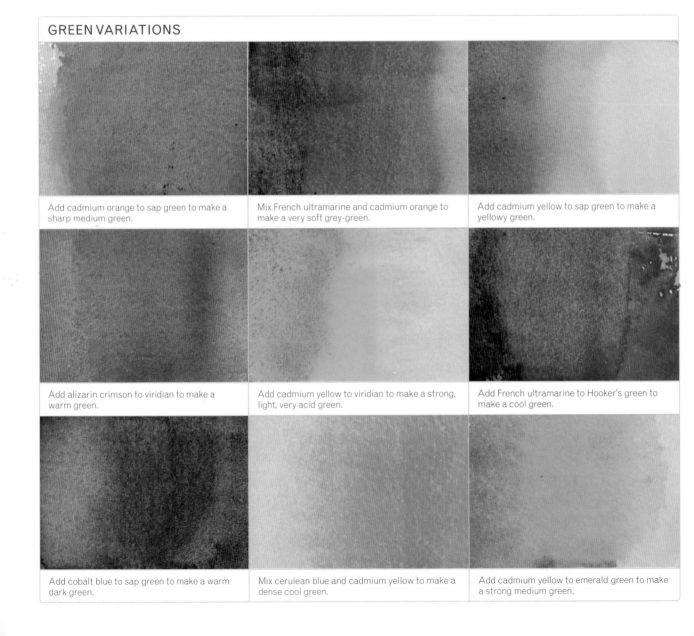

Add cadmium orange to sap green to make a sharp medium green.

Mix French ultramarine and cadmium orange to make a very soft grey-green.

Add cadmium yellow to sap green to make a yellowy green.

Add alizarin crimson to viridian to make a warm green.

Add cadmium yellow to viridian to make a strong, light, very acid green.

Add French ultramarine to Hooker's green to make a cool green.

Add cobalt blue to sap green to make a warm dark green.

Mix cerulean blue and cadmium yellow to make a dense cool green.

Add cadmium yellow to emerald green to make a strong medium green.

SKIN TONES

All skin tones, from the palest to the darkest of complexions, are made up of a combination of three colours: red, yellow, and blue. Therefore, it is possible to mix all skin colours with a very limited selection of paints: raw sienna, alizarin crimson, cerulean blue, and cadmium red. When you paint skin remember it is reflective so will also be affected by the colours around it.

Pure colours

Raw sienna

Alizarin crimson

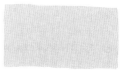

Cerulean blue

Cadmium red

Colour mixes

Raw sienna and alizarin crimson

Raw sienna and cerulean blue

Alizarin crimson and cerulean blue

Raw sienna, alizarin crimson, and cerulean blue

Raw sienna and alizarin crimson make a soft, even skin tone, which can be used for all skin types.

Cool down a raw sienna and alizarin crimson mix with cerulean blue to help model a face.

Raw sienna and cadmium red make a strong colour suitable for tanned or dark skin.

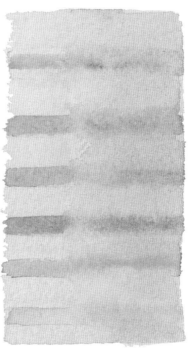

Layering colours wet on dry creates luminous skin tones, which can be softened with water, as on the right-hand side.

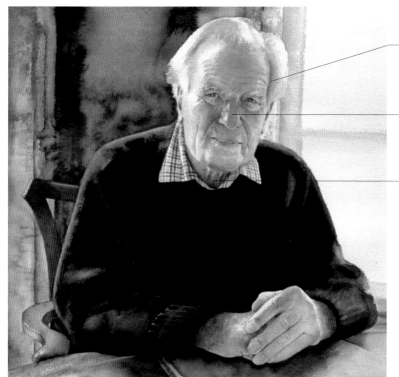

Alizarin crimson is used on the side of the face.

Warmer colours are used down the centre of the face.

Dark tones mixed from pink, yellow, and blue look soft.

Portrait of a man This face has been painted using raw sienna, alizarin crimson, cerulean blue, and cadmium red. The colours have been built up slowly from light to dark to create a radiant face.

Washes

Washes are the foundation of watercolour painting, as they are the first application of paint to the paper, whether as a tinted ground or a large painted area. Laying a wash, therefore, is a vital technique to master. Once you have practised producing a smooth, flat wash in a single colour, you can vary the basic technique to create graded washes, variegated washes, and broken washes.

FLAT WASH

Dampen the paper and tilt your drawing board slightly. With a large flat brush, paint a band across the top of the paper.

Starting at the other side of the paper, paint the next band so that it overlaps the first. Repeat to the bottom of the paper. Dry with the paper tilted.

In a flat wash, the bands of paint blend together while they are still wet to create a smooth wash of uniform colour.

GRADED WASH

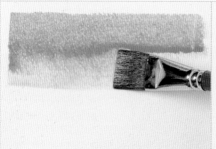 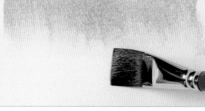 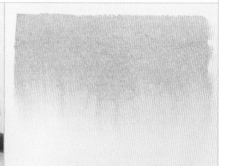

Dampen the paper and lay a wash across the top. Immediately add water to the paint and add another band of paint at the base of the first band.

Add more water to your paint and repeat. Continue to dilute the paint for each band of paint, until you reach the bottom. Allow to dry.

A graded wash becomes progressively lighter towards the bottom, as each band of paint is more diluted than the previous one.

VARIEGATED WASH

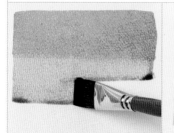

Paint two bands of a wash at the top of the damp paper. Load your brush with a different colour and paint this below the first colour.

Let the bands of paint blend on the paper. To produce a more colourful result, introduce a different colour with each new stroke.

BROKEN WASH

Hold your brush low on the paper so that you drag the colour over the surface, letting the paper's texture break up the bands of paint.

You can vary the position of the broken marks by letting the brush glance across the paper in different places to create texture.

USING WASHES

Below you can see some of the many different ways in which washes can be used. While a flat wash is good for painting large areas and backgrounds, more complex washes can express mood or be used for natural elements. Graded washes, for example, give skies a sense of depth. Variegated washes, on the other hand, are excellent for colourful sunsets.

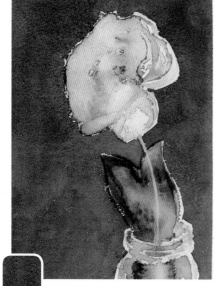

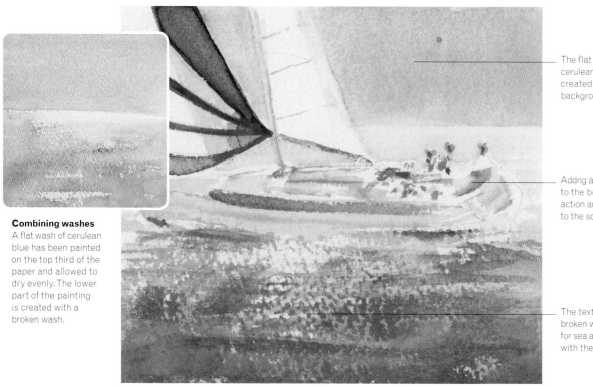

Combining washes
A flat wash of cerulean blue has been painted on the top third of the paper and allowed to dry evenly. The lower part of the painting is created with a broken wash.

The flat wash of cerulean blue has created a calm background sky.

Addng a few details to the boat brings action and purpose to the scene.

The texture of the broken wash is good for sea and contrasts with the calm sky.

Flat wash

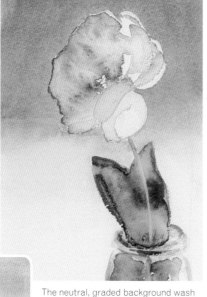

The flat background wash makes the colours of the flower really stand out in contrast.

Graded wash

The neutral, graded background wash is pale at the bottom, making the leaves and jar stand out.

Variegated wash

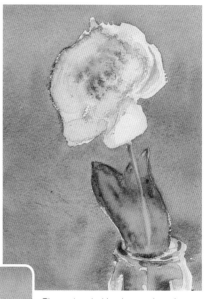

The variegated background wash is colourful and suggests an area of interest behind the flower.

Building a painting

Watercolour paintings can be built up by adding layers of paint either to paint that has already dried – wet on dry – or to colour that is still wet – wet-in-wet. Laying down paint wet on dry produces vivid colours with strong edges. You can paint wet on dry with a high level of accuracy so it is a good technique to choose when painting detail. Wet-in-wet is more immediate and the results, produced as the colours blend, are softer and less predictable. Wet-in-wet is useful for backgrounds and the early stages of a painting.

WET OR DRY?

Try out these two techniques to see the effects they produce. Practising will also help you to judge how wet or dry your paper is, which helps you to anticipate the effect your painting will produce. If paint is added to a wash before it is completely dry, particularly on smooth paper, it may cause backruns as the second colour runs into the first and dries in blotches with hard edges.

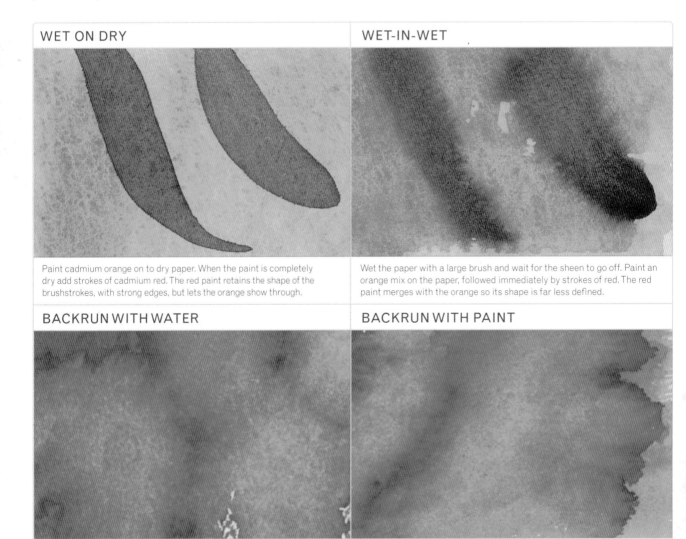

WET ON DRY

Paint cadmium orange on to dry paper. When the paint is completely dry add strokes of cadmium red. The red paint retains the shape of the brushstrokes, with strong edges, but lets the orange show through.

WET-IN-WET

Wet the paper with a large brush and wait for the sheen to go off. Paint an orange mix on the paper, followed immediately by strokes of red. The red paint merges with the orange so its shape is far less defined.

BACKRUN WITH WATER

Paint a red wash and allow it to half dry. While the paper is still damp, add spots of water with the tip of a round brush. The water pushes the red paint out to create circles.

BACKRUN WITH PAINT

Paint an orange wash and allow to half dry. Drop in a watery mix of red. The red runs back into the orange to create cauliflower-like shapes with hard edges and diluted centres that let the orange show through.

WET-IN-WET STUDY

As painting wet-in-wet is not predictable, it is a good idea to practise studies whenever you can. Here the method has been used to quickly capture the head of a tiger and paint the soft texture of its thick, colourful fur.

The background is painted with raw sienna

The strong mix of burnt sienna creates the texture of the fur.

The stripes of burnt umber are added when the paint has dried a little.

BACKRUN STUDY

Backruns sometimes appear by mistake but you can use them to enhance your paintings. Because of their spontaneity, use backruns when you are free to interpret the marks you end up with. Here cauliflower-like shapes have been made into autumnal leaves.

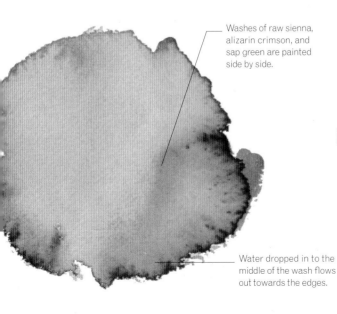

Washes of raw sienna, alizarin crimson, and sap green are painted side by side.

Water dropped in to the middle of the wash flows out towards the edges.

Once the wash is dry, look for shapes you can interpret.

Paint effects

You can add texture and interest to your paintings with a number of special effects. These include splattering and sponging, and techniques using materials that resist the flow of paint on the paper and make it dry in a striking pattern, as when tin foil or salt are used. As the results of these methods can be unpredictable, have fun experimenting with them and build up the range you can use in your paintings. Try using cling film to create the ripples on water, salt to make snow or ice, and splattering and sponging for foliage.

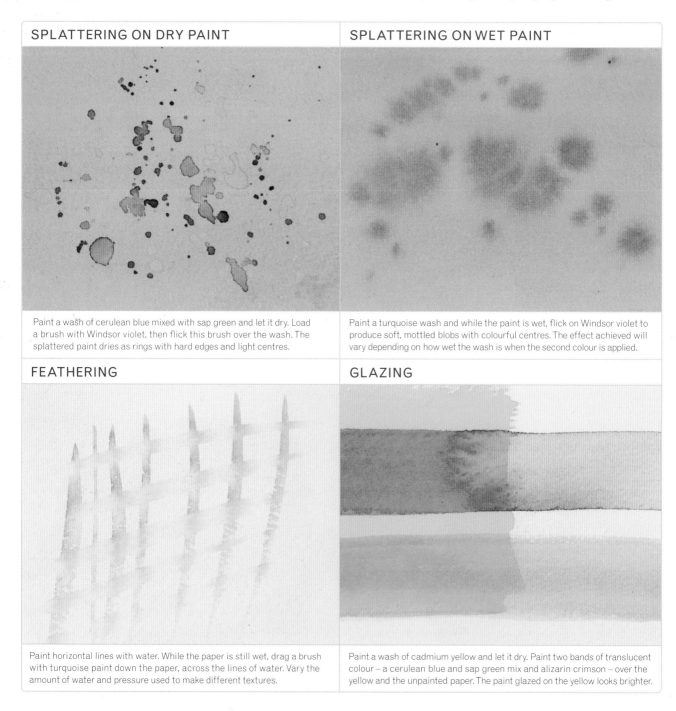

SPLATTERING ON DRY PAINT

Paint a wash of cerulean blue mixed with sap green and let it dry. Load a brush with Windsor violet, then flick this brush over the wash. The splattered paint dries as rings with hard edges and light centres.

SPLATTERING ON WET PAINT

Paint a turquoise wash and while the paint is wet, flick on Windsor violet to produce soft, mottled blobs with colourful centres. The effect achieved will vary depending on how wet the wash is when the second colour is applied.

FEATHERING

Paint horizontal lines with water. While the paper is still wet, drag a brush with turquoise paint down the paper, across the lines of water. Vary the amount of water and pressure used to make different textures.

GLAZING

Paint a wash of cadmium yellow and let it dry. Paint two bands of translucent colour – a cerulean blue and sap green mix and alizarin crimson – over the yellow and the unpainted paper. The paint glazed on the yellow looks brighter.

USING SALT

Drop salt crystals on to an alizarin crimson wash and let it dry. Brush off the salt to reveal the shapes made by the salt absorbing the paint. The effect will vary depending on how wet the paint is and how much salt you use.

SPONGING

Dip a natural sponge into a wash of alizarin crimson, then press the sponge on to dry watercolour paper. The mottled marks you make will vary depending on the amount of paint used and how hard you press.

USING CLING FILM

Paint a Windsor violet wash. While it is wet, scrunch up some cling film and press it on to the paper. Let the paint dry before removing the cling film, so that the paint keeps the hard edges formed where the film has touched it.

USING TIN FOIL

Press tin foil into wet paint using the same technique used for cling film. The effect is stronger than that produced by cling film but you cannot see the effect being made while the paint is drying.

SCRAPING BACK

Paint the rough shapes of a loose stone wall using a mix of cerulean blue and burnt umber, letting the colours blend. While the paint is wet, scrape out the shapes of the stones using a plastic strip – such as an old credit card – to remove the wet paint.

Composition

When planning a painting, you have to decide what you want to focus on in your picture and what you want to leave out. Simplicity is the key to success when you start painting, and editing will strengthen your composition. You will also need to choose where you position the different elements of your painting. In a successful composition they will be placed so that they lead the viewer into the painting.

VIEWFINDER

Use a viewfinder as a framing device that you can move in front of your subject to help you visualize how it will look in a variety of compositions. You can make a simple viewfinder by holding two L-shaped pieces of card to make a rectangle, as shown on the right. You can change the shape and size of the rectangle by moving the pieces of card closer to each other or further apart.

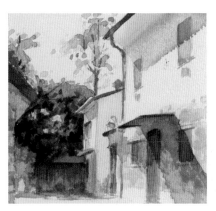

Slide the corners of the card in and out to frame and crop the picture.

FORMAT

Deciding what format – shape of paper – to use is an important part of planning a composition. The three paintings below show how the choice of format can direct attention to different focal points. The formats used for this study are: portrait (a vertical rectangle, higher than it is wide), landscape (a horizontal rectangle, wider than it is high), and square.

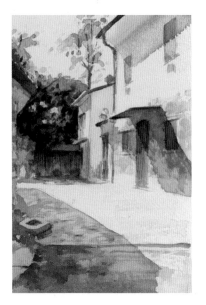

Landscape format The horizontal nature of this picture draws attention to the colourful shed doors and angles of the trees. The building on the left directs the eye to to the centre of the composition.

Square format Here the roofs and doorways have been included. The trees on the left act as a counterpoint to this detail on the right and help to create a balanced composition.

Portrait format The large amount of space given to the foreground in this design leads the eye along the road and into the picture.

USING THE RULE OF THIRDS

To help you plan your composition and give it visual impact, try using the rule of thirds. Divide your paper into thirds both vertically and horizontally to make a nine-box grid. At first you may want to draw these lines on the paper with a pencil, but with practice the grid can be imaginary. For maximum effect, position the main elements of your design on the lines. Place the horizon line, for example, a third up from the bottom or a third down, and use the points where the lines intersect for your areas of interest.

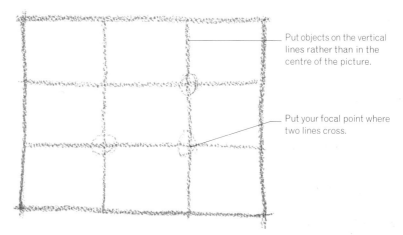

Put objects on the vertical lines rather than in the centre of the picture.

Put your focal point where two lines cross.

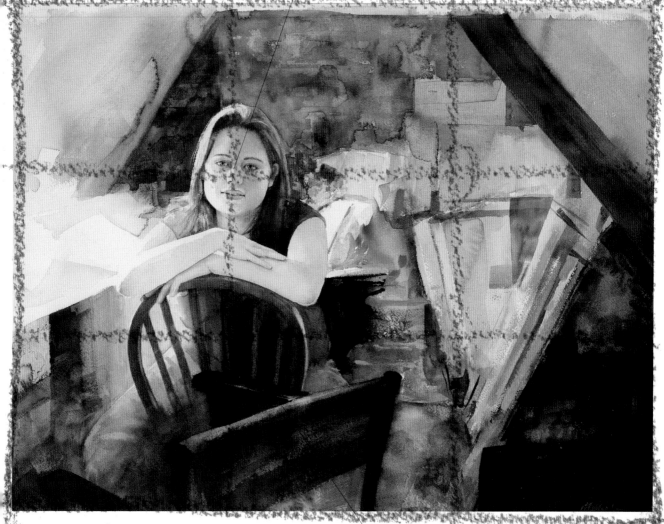

The focal point, the face, has been placed where two lines intersect.

The lines of the chair draw the eye into an otherwise empty area.

Artist in her studio

Girl in artist's studio This painting of a figure in a clutter of objects and colours could have looked quite chaotic, but because the areas of interest have been placed according to the rule of thirds the composition is well balanced and pleasing to the eye.

Sketching

Simple sketches are very useful when planning a watercolour painting. You can develop rough ideas, sketched in pencil, into compositions, and use watercolour sketches to help you plan the colours you want to use and to practise marks and colour mixes.

Use a sketchbook to keep all your ideas together and to record things you see that inspire you, so that you build up your own valuable reference. Copy out developed compositions on to watercolour paper and use the pencil lines as a guide when you begin painting.

USING SKETCHBOOKS

Many sketchbooks contain cartridge paper with a smooth surface. This is fine for pencil sketches, but if you want to use soft pencils, graphite sticks, and watercolour to sketch with, choose a sketchbook that contains paper with a slightly rough surface. It is a good idea to buy a pocket-size sketchbook and carry this around so that you can sketch whenever you are inspired.

Project sketch

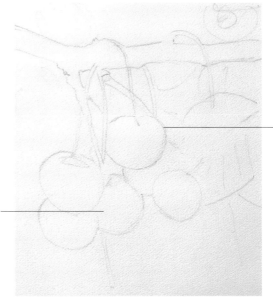

The drawing is done lightly, as it will remain under the washes and brushmarks of the finished painting.

Don't use watercolour paper for planning sketches, as alterations and erasings will damage the paper's surface.

A sketch for the Cherries project (see pp.52–55) was copied on to watercolour paper before painting began.

Quick colour sketch

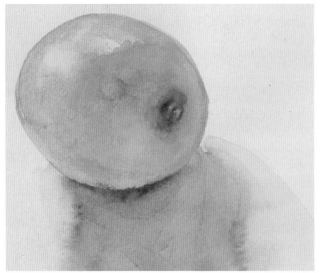

Quick colour sketches, such as this one of a lemon, are a good way to experiment with different colour combinations and techniques.

Planning a composition

This sketch has been used to plan which colours to use in a painting. Just a few brushstokes are sufficient.

COLOUR TEST SHEETS

This page from a sketchbook shows the marks and sketches that were made when planning the Cherries project *(see pp.52–55)*. Colour mixes were tested and techniques such as wet-in-wet and softening were practised to help discover the best way of painting the cherries. Test sheets often influence the final design of a painting, as they highlight interesting and successful effects.

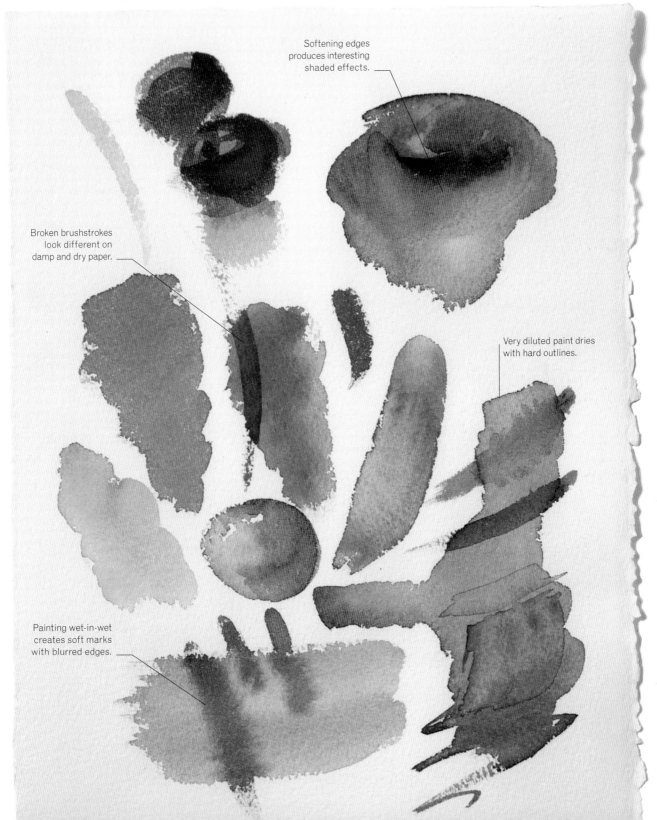

Softening edges produces interesting shaded effects.

Broken brushstrokes look different on damp and dry paper.

Very diluted paint dries with hard outlines.

Painting wet-in-wet creates soft marks with blurred edges.

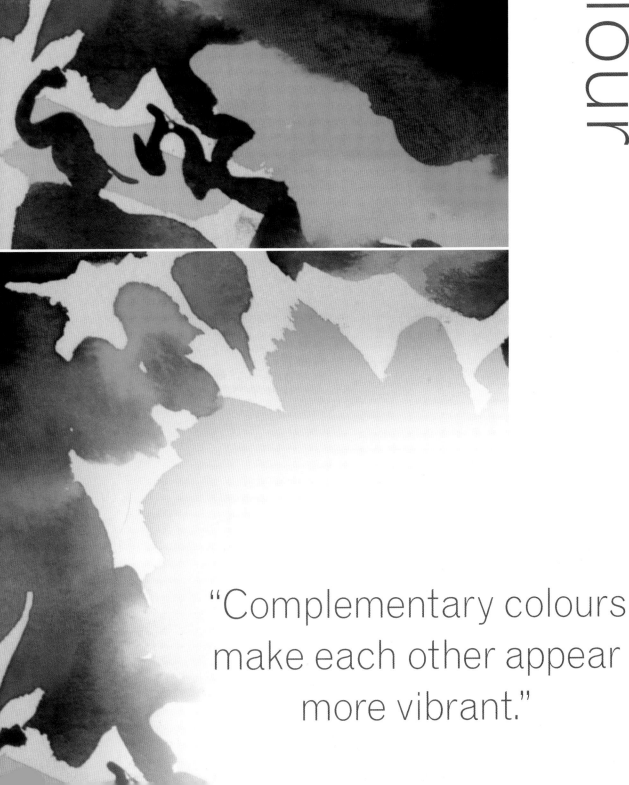

"Complementary colours
make each other appear
more vibrant."

Vibrant colours

To create a really vibrant painting, you need to plan which colours to use. If you try to reproduce all the colours you see in front of you, they end up vying with each other, rather like all the instruments in an orchestra playing at once. If, on the other hand, you try limiting the colours you use in a painting to complementary opposites, such as red and green, you will find that the colours make each other appear more vibrant. The reds will look much more red and the greens will appear more intensely green.

COMPLEMENTARY COLOURS

There are three primary colours: red, yellow, and blue. These are colours that can't be made by mixing other colours together. Green, orange, and purple are called secondary colours. Each of these is made by mixing two primary colours together. Green, for example, is made by mixing blue and yellow together. Complementary colours are pairs of colour that are opposite each other on the colour wheel. The complementary colour of any secondary colour, therefore, is the primary colour it does not contain.

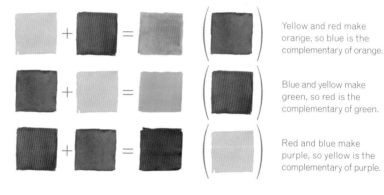

Yellow and red make orange, so blue is the complementary of orange.

Blue and yellow make green, so red is the complementary of green.

Red and blue make purple, so yellow is the complementary of purple.

COLOURFUL NEUTRALS

If you mix two complementary colours together in equal proportions, they produce a neutral colour. By varying the proportions of the mix, you can create a harmonious range of neutral greys and browns. These neutrals are far more luminous and colourful than ready-mixed greys and browns, and are excellent for creating areas of tone. If your painting is based around red and green, for example, the areas of tone would be made from varying mixes of red and green.

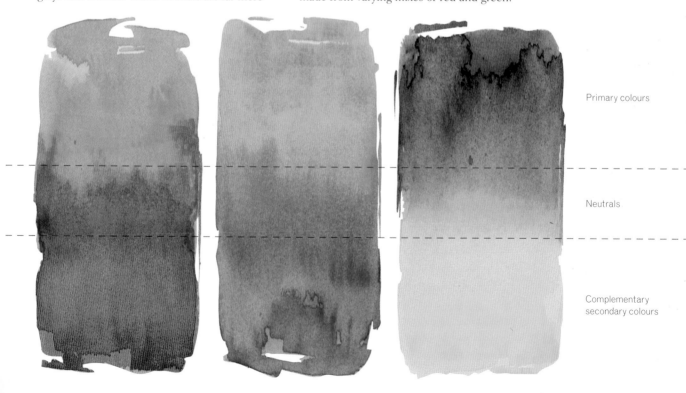

Primary colours

Neutrals

Complementary secondary colours

HARMONIOUS PAINTINGS

Colour is one of the most direct ways of expression available to you when you paint. The instant you use colours together they form an association with one another that helps to suggest the mood of the painting. Limiting colours to complementary opposites enables you to create simple, vibrant paintings with a range of harmonious tones.

Red and green

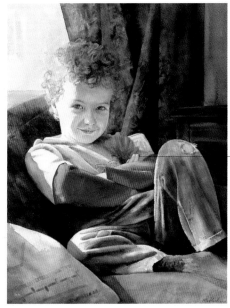

The green body of the T-shirt makes the red arms stand out.

Red is a forceful colour and is made more vibrant here by its proximity to green. The boy's pose is relaxed but the liveliness of the red hints at his boisterous nature.

Yellow and purple

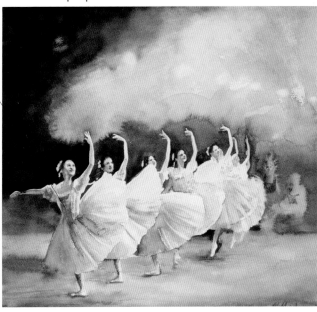

The reflective yellow contrasts with the dark purple.

Yellow is a reflective colour and here it is used in the dancers' skirts to reflect the glare of strong stage lighting. Counterbalancing the yellow with purple highlights the illuminated skirts and helps to ground the dancers' feet.

Blue and orange

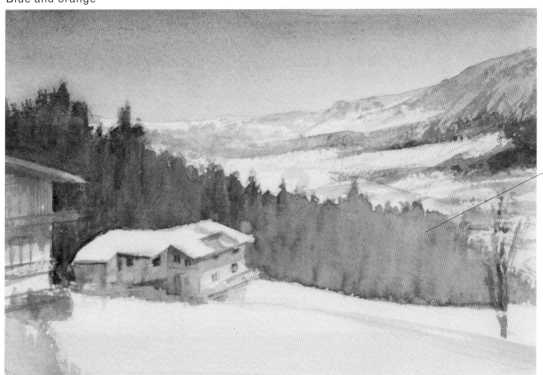

Orange and blue have been mixed together to create a range of green neutrals for the trees.

The dominance of blue in this scene suggests cold, still mountain air, in contrast with the orange areas that suggest sunshine and warmth.

Gallery

Complementary colours make each other appear more vibrant
and can be used to create simple, harmonious paintings.

▲ Corn

Painting the orange-yellow ear of corn in
the foreground against a complementary
blue sky makes it really stand out. The use
of yellow and purple, and red and green
elsewhere adds vibrancy. *Peter Williams*

◄ Tuscan house

The orange and yellow house is
surrounded by complementary blues
and lilacs. The use of complementary
blue for the window draws attention
through the foreground to the house.
Glynis Barnes-Mellish

▲ Sunflowers

This bold, loose painting shows a
controlled use of complementary
colours. The strong splash of yellow
is heightened by the flowers' purple
centres, and the green leaves balance
the reds. *Phyllis McDowell*

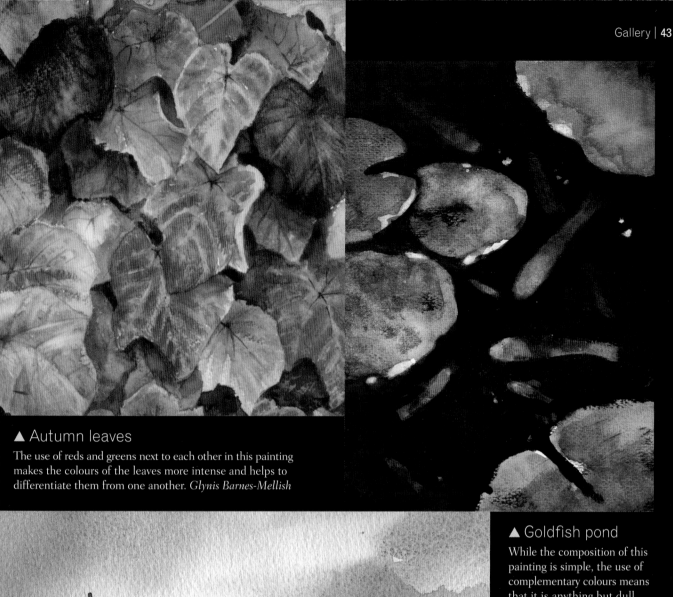

▲ Autumn leaves

The use of reds and greens next to each other in this painting makes the colours of the leaves more intense and helps to differentiate them from one another. *Glynis Barnes-Mellish*

▲ Goldfish pond

While the composition of this painting is simple, the use of complementary colours means that it is anything but dull. The bright red goldfish appear stunningly vibrant, a result of them being positioned among strong green lilies. *Robert McIntosh*

◀ Church in field

This atmospheric scene makes use of two sets of complementary colours. The soft use of blues and purples in this painting suggests cloud and mist and is balanced by the complementary yellows and oranges of winter sunlight. *Phyllis McDowell*

⬜1 Tuscan landscape

At first sight, landscapes look both colourful and rather complex, especially if they are made up of many different shades of green. In this painting, however, orange and blue – complementary colours – are used not only to create a dramatic and vibrant composition, but are also mixed together to make a harmonious range of neutral greens and greys. The sky makes up two thirds of the painting and a basic flat wash is used to great effect to capture the appearance of a deep blue sky on a still, hot summer's day.

EQUIPMENT

- Cold-pressed paper
- Masking tape
- 4B pencil
- Brushes: No. 14, 25mm (1in) flat, hake, squirrel
- Kitchen towel
- Cobalt blue, cadmium orange, French ultramarine, cadmium red, burnt sienna

TECHNIQUES

- Flat wash
- Graded wash

PREPARATION

Lightly sketch the outlines of the composition with a soft (4B) pencil, to act as a guide for your painting.

Stick masking tape around the edges of the picture area. This will define the edges of the painting and will help to keep them clean.

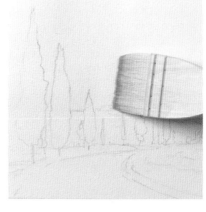

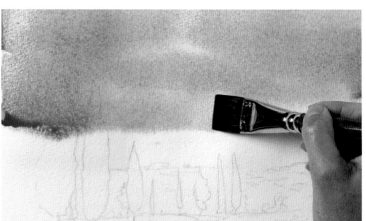

1 Use the hake brush to wet the paper in horizontal lines, starting at the top of the picture area and working down to the horizon line. Mop up any excess water with clean kitchen towel.

2 Mix a generous amount of cobalt blue on your palette, enough for a wash. When the wet paper has lost its sheen, load the 25mm (1in) flat brush with cobalt blue and apply a flat wash of colour for the sky.

BUILDING THE IMAGE

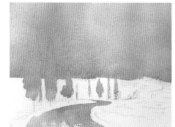
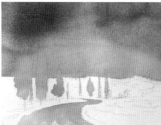
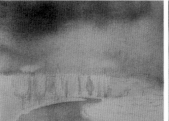
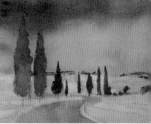

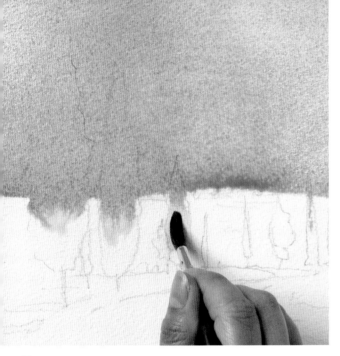

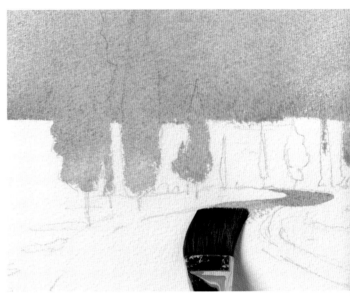

3 Use a squirrel brush that has been dipped in water to soften the lower edge of the wash and to bring the blue down on to the trees along the road.

4 Load the 25mm (1in) flat brush with the cobalt blue that is already mixed on your palette. Use this paint to create the curving road.

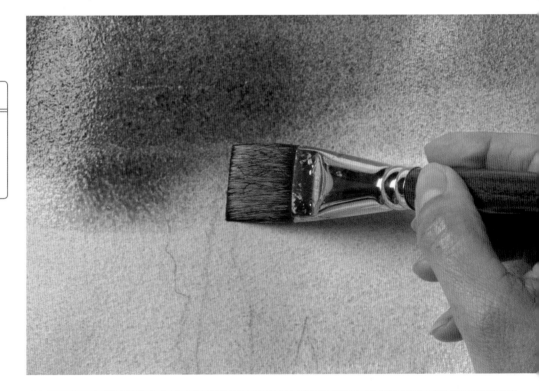

GRADED WASH

As the cobalt blue is still wet, the second wash of French ultramarine, which is darker, blends into it, creating a graded wash.

5 With the 25mm (1in) flat brush, apply two stripes of a French ultramarine wash over the cobalt blue wash at the top of the picture.

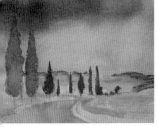
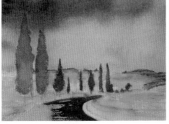
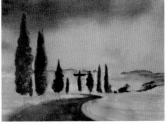
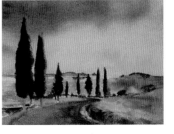

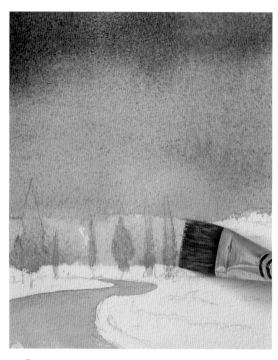

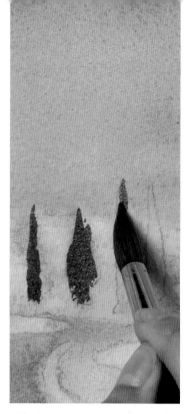

6 When the trees and road are dry to the touch, apply a wash of cadmium orange below the blue wash of the sky with the 25mm (1in) flat brush. The trees and road will look green where you have painted over them.

7 Wait for the orange paint to dry a little and lose its sheen. Using a soft brush, gently dab water on to the orange paint to push it away. This will add texture to the fields.

8 Mix French ultramarine and cadmium orange to make a soft green for the trees. Don't overload your brush so the strokes break up slightly to create the trees' texture.

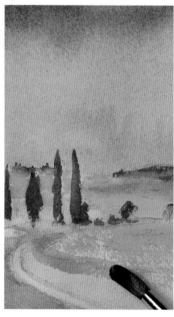

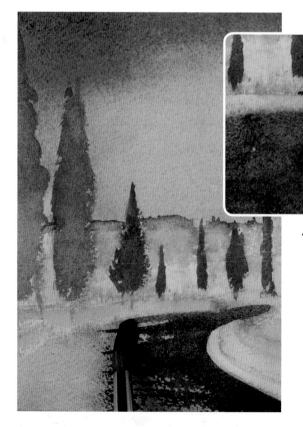

10 Paint the road with a mix of burnt sienna and French ultramarine. Add cadmium red and cobalt blue to make grey, and strengthen some areas by mixing in French ultramarine on the paper.

9 Paint trees on the horizon with the green mix and soften them. When the orange wash is dry, add cadmium orange mixed with a little cadmium red to brighten the fields.

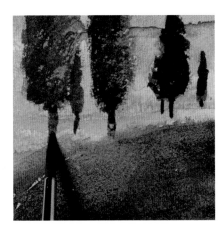

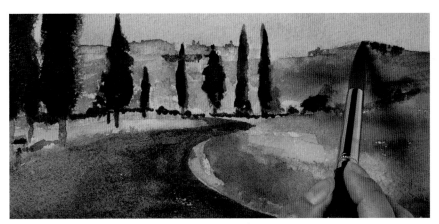

11 Mix cadmium red and cobalt blue for the tree trunks. Darken the foliage with a burnt sienna and French ultramarine mix. Paint the shadows with a mix of cobalt blue, cadmium red, and cadmium orange, and then soften them.

12 Add a mix of cobalt blue and cadmium red to the horizon, to create depth. Paint grass in the foreground of the picture, then strengthen the colour between the trees with touches of cadmium orange.

▼ Tuscan landscape

The complementary washes of orange and blue create a colourful final painting. Simple mixes of these colours produce the greens for the trees and a range of harmonious tones for the finer details.

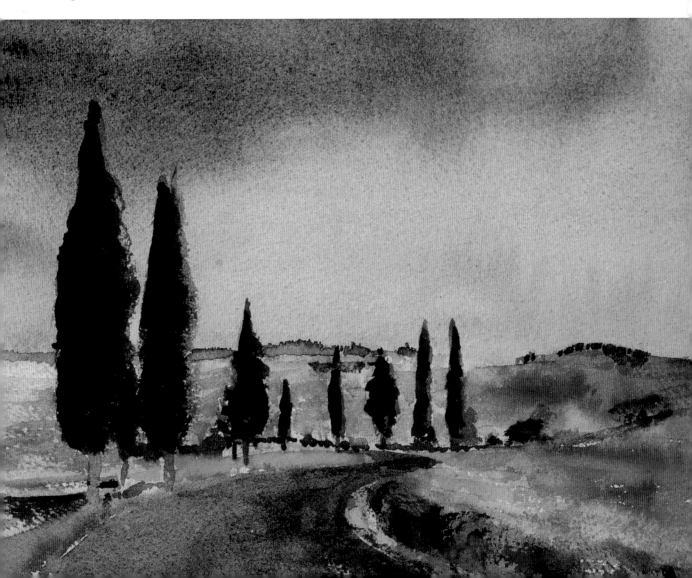

2 Ballet shoes

In this painting the golden tones of the ballet shoes and barre are set against a predominantly neutral background. Applying the background wet-in-wet as different shades of cool lilac creates a complementary, harmonious combination of colours. The lilac is also reflected in the satin surface of the ballet shoes, which helps to emphasize their soft sheen. Although there are some warm colours used in the background, they recede in comparison with the rich gold of the ballet shoes, and this helps to bring the shoes right to the front of the painting.

EQUIPMENT
• Rough paper
• Brushes: No. 5, No. 14, 25mm (1in) flat
• Cerulean blue, raw sienna, Windsor violet, burnt sienna, cadmium orange, cadmium red, cadmium yellow

TECHNIQUES
• Wet-in-wet

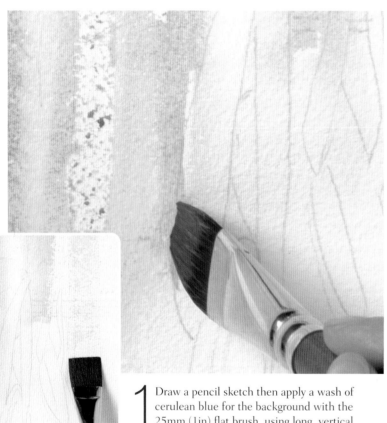

1 Draw a pencil sketch then apply a wash of cerulean blue for the background with the 25mm (1in) flat brush, using long, vertical strokes. Leave the window areas white and add strokes of raw sienna on their frames.

2 Paint vertical strokes of diluted Windsor violet on the right-hand side of the picture with the 25mm (1in) flat brush. The Windsor violet will run into the wet raw sienna, keeping the edges soft.

BUILDING THE IMAGE

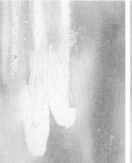

3 Use raw sienna to paint the wooden barre and the ballet shoes, letting the colour run into the purple background. Strengthen the cerulean blue, keeping the white areas of paper clear.

4 Mix cerulean blue and raw sienna for the barre supports. Add a burnt sienna and Windsor violet mix to the background. Strengthen the barre with raw sienna and a touch of cadmium orange.

5 Use a cerulean blue and Windsor violet mix to paint horizontal lines on the left. Darken the back wall with a burnt sienna and cerulean blue mix. Paint inside the shoes with a mix of burnt sienna and Windsor violet.

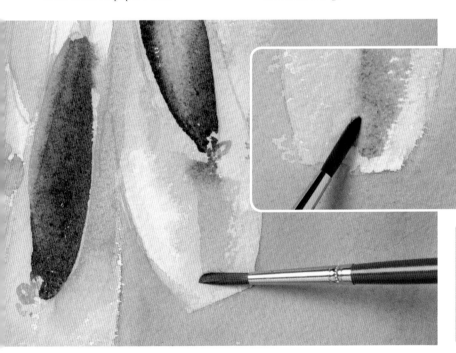

6 Strengthen the colour of the shoes with raw sienna mixed with a little cadmium orange. Paint vertical lines of cerulean blue to create their satin sheen. Add Windsor violet wet-in-wet, then lines of burnt sienna.

STRENGTHENING COLOURS

As paint dries, colours tend to become paler. If the dried result is too pale, you can strengthen the colour by adding further layers of paint.

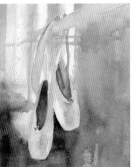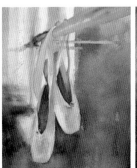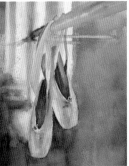

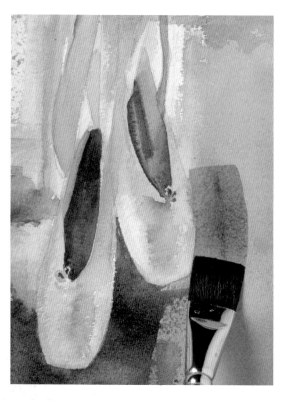

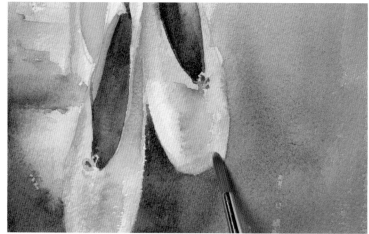

7 Paint the shoe ribbons with a mix of cerulean blue and raw sienna and add definition with a mix of Windsor violet and raw sienna. Strengthen the background around the shoes with the mix of Windsor violet and raw sienna. This helps to bring the shoes forward.

8 Add raw sienna to the background on the right side. Warm up the shoes with a mix of cadmium red and raw sienna. Strengthen the dark parts of the shoes with the mix of Windsor violet and burnt sienna. Paint the block toes with raw sienna.

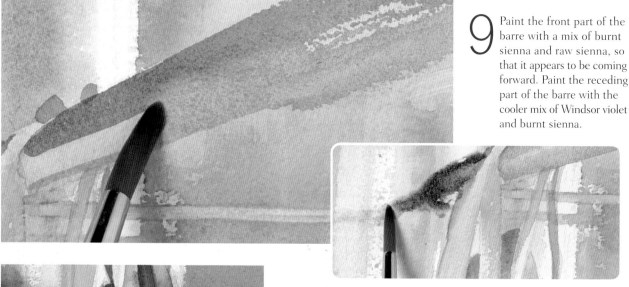

9 Paint the front part of the barre with a mix of burnt sienna and raw sienna, so that it appears to be coming forward. Paint the receding part of the barre with the cooler mix of Windsor violet and burnt sienna.

10 Add a wash of Windsor violet to the right-hand side of the picture, to create a contrast with the yellow shoes. Paint the shoe ties with the mix of Windsor violet and burnt sienna. Add raw sienna and cadmium yellow to the fronts of the shoes to make them more vibrant.

Ballet shoes ▶

A dynamic picture has been created from the relationship between the bold main image and the wash of colours behind it. The build-up of golden tones and the strength of the complementary lilac has produced a luminous and striking image.

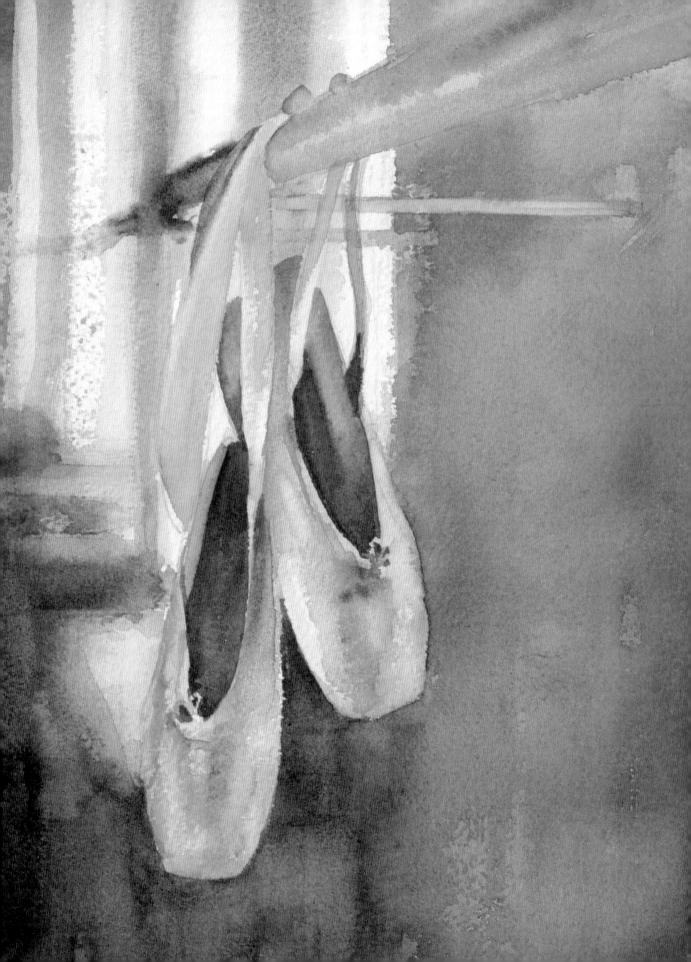

③ Cherries

Close studies can make highly rewarding paintings. By cropping in tightly on a small bunch of cherries in this straightforward study, attention is focused on the fruit and there is no need for unnecessary detail. In order to emphasize the vibrant red of the cherries, its complementary colour – green – is used for the rest of the painting. The soft, loose washes of different greens create a calm, recessive background, which throws the vivid scarlet of the cherries into relief so that they appear to come forward and completely dominate the painting.

EQUIPMENT

- Cold-pressed paper
- Brushes: No. 5, No. 9, 12.5mm (½in) and 25mm (1in) flat
- Alizarin crimson, cadmium red, cadmium yellow, burnt umber, French ultramarine, viridian, Windsor violet, emerald green, cerulean blue

TECHNIQUES

- Wet-in-wet
- Softening edges

1 Use touches of alizarin crimson to paint the lighter areas of the cherries, taking care not to overload your brush. Paint the rest of the cherries cadmium red and soften the edges with water to remove some paint.

2 Remove a little of the wet cadmium red by dabbing it with a clean tissue. This takes you back to the alizarin crimson that was covered by cadmium red in step 1. The contrast between the two colours makes the cadmium red look brighter.

BUILDING THE IMAGE

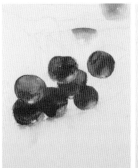
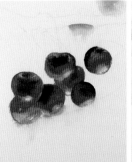
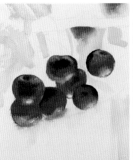
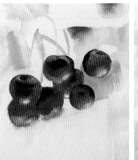
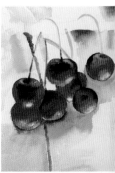

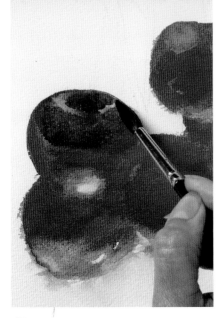

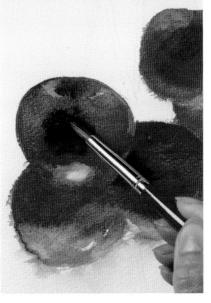

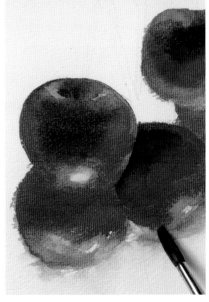

3 Create shadows with Windsor violet then add another layer of cadmium red to strengthen the colour of the cherries. Use a wet brush to soften some areas to create highlights. Strengthen the alizarin crimson.

4 Mix cadmium red and burnt umber to make a dark red and paint this on to the cherries while the cadmium red is still wet. This darker mix creates the shadows of the cherries that are furthest away.

5 Use pure Windsor violet to outline part of the cherries and separate them from each other. Strengthen the red again, to push back the darker colours, and soften the edges to show where the light falls on them.

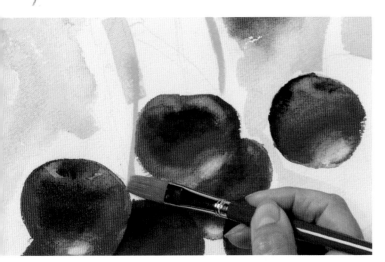

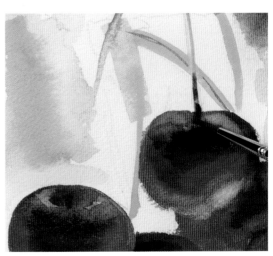

6 Paint washes of emerald green, cadmium yellow, and cadmium red wet-in-wet in the background. Keep the colours loose and wet so that they appear to recede. Use the side of the 12.5mm (½in) flat brush to paint fine green lines for the stems of the cherries.

7 When the cherries are dry, paint the leaf with emerald green and cerulean blue. Use a mix of French ultramarine and burnt umber to indicate where the stalks meet the cherries.

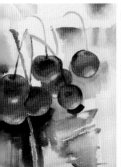
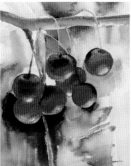
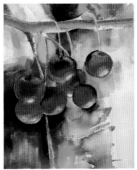
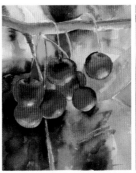
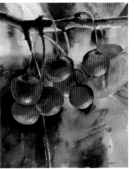

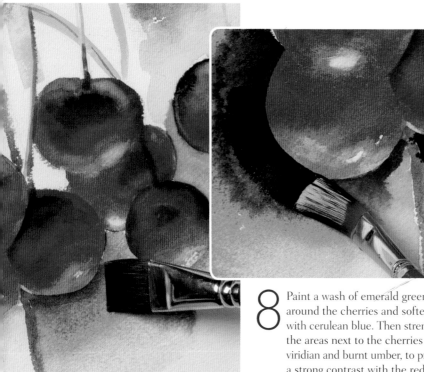

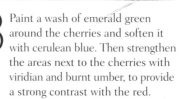

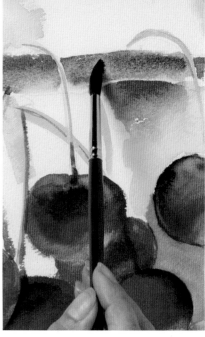

8 Paint a wash of emerald green around the cherries and soften it with cerulean blue. Then strengthen the areas next to the cherries with viridian and burnt umber, to provide a strong contrast with the red.

9 Paint the branch above the cherries with burnt umber, using the side of the No. 5 brush. The paint will granulate naturally, helping to create the mottled appearance of the bark on the branch.

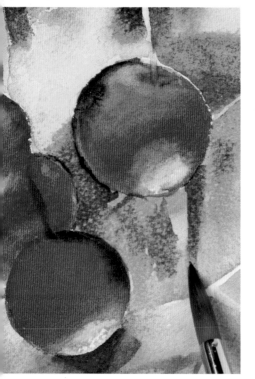

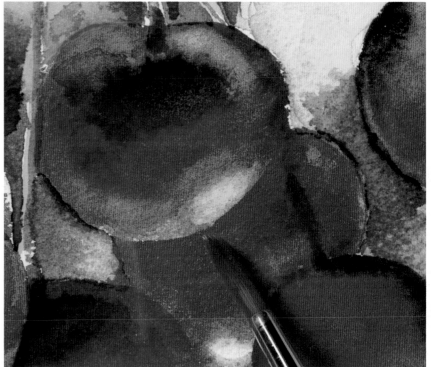

10 Fill in the background with broad washes of greens. Paint the leaf with a mix of cerulean blue and cadmium yellow, then add strokes of cerulean blue and viridian to create the leaf veins.

11 Paint the shadows on the cherries with a mix of cadmium red and alizarin crimson. Strengthen the colour of the branch with burnt umber and add Windsor violet in the darkest places.

Cherries ▶

The dramatic effect of the finished painting is achieved by the striking contrast between the scarlet cherries and the complementary washes of green around them.

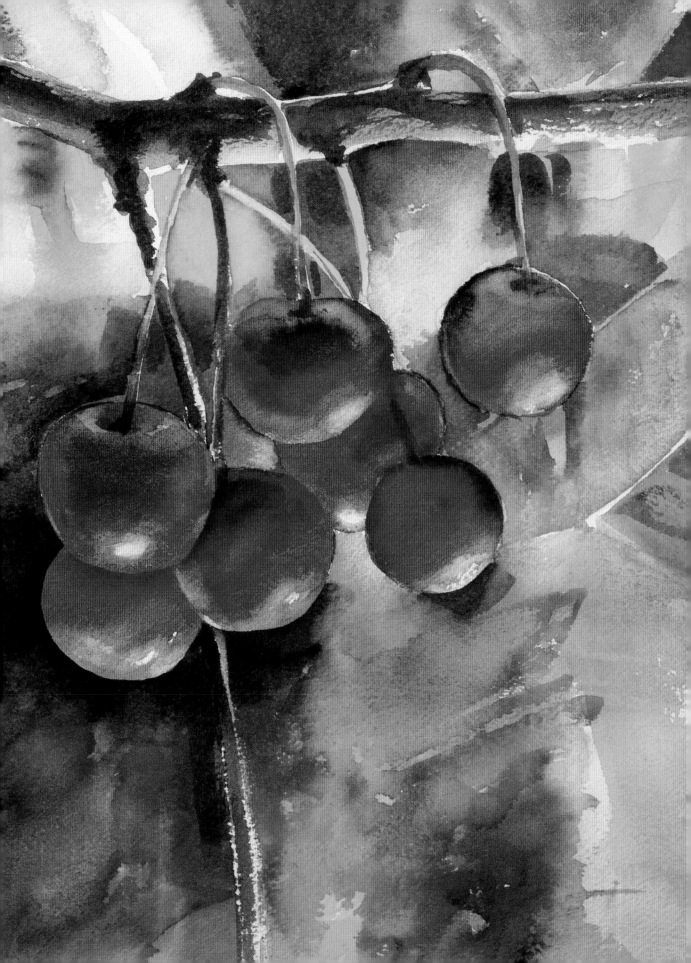

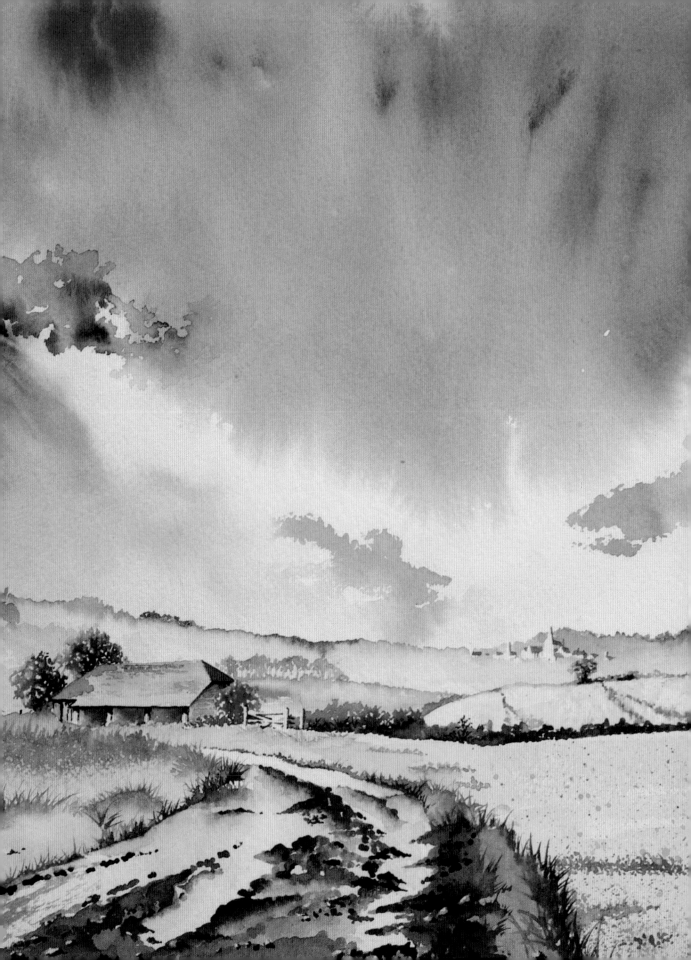

"Plan your colours:
limit your palette."

Light and dark

Tone – the relative lightness or darkness of colours – is the most important building block for all painting. It creates pattern and shape, movement and design. Colour, depth, and focus are all diminished without good, clear use of tone. A painting in which all the colours are of a similar tone looks dull because there are no high notes or low notes – nothing stands out. To create subtle paintings full of energy and interest, it is best to limit the colours you choose and to use neutrals to create a varied range and depth of tone.

LIMIT YOUR PALETTE

Working with a limited range of colours that are close together on the colour wheel holds a painting together and gives it unity. The colours can be based around any one of the primary colours and will each contain a certain amount of that colour. Including one complementary colour in your selection will enable you to create a range of harmonious neutrals and semi-neutrals that also unify the painting. Using a very small amount of the pure complementary colour in your painting will give emphasis to the composition and make the colours sparkle.

In the colour wheel all the colours are equal in tone, so no one colour stands out.

Limited palette of yellow-green, green, blue-green, and complementary red.

Limited palette of blue-green, blue, blue-purple, and complementary orange.

Limited palette of blue-purple, purple, red-purple, and complementary yellow.

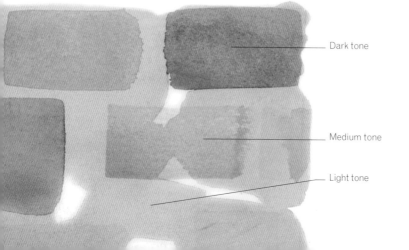

Dark tone

Medium tone

Light tone

SELECTING TONES

Using a simple range of close tones in your painting will help to hold all the different elements of your composition together. Most paintings only need a range of three close tones, accented by a few very dark tones and the white of the paper to create drama and focus. Make sure that you have identified all the tones in a scene before you decide where to simplify them. To help you see the tone of an object, compare it with the colours surrounding it. You may also find it useful to hold a piece of white paper next to the tone to see how light or dark it is when compared with white.

PAINTING WITH A LIMITED PALETTE

Before beginning a painting, try making a preliminary sketch of your subject. Use the sketch to help you work out which range of colours and tones to use to create a strong composition.

The simple watercolour sketch on the right was made in preparation for the painting below and many of the tones used were corrected, to create a more dynamic painting. In the finished painting the palette is limited, with green as the dominant colour. Using a range of greens has made the foliage interesting even though it is not very detailed. The tonal range of the neutral colours gives the painting structure, and the small amount of complementary red makes the painting more vibrant.

Preliminary sketch

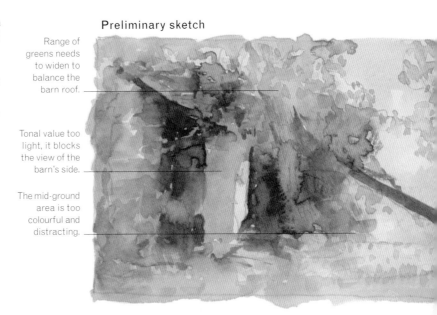

Range of greens needs to widen to balance the barn roof.

Tonal value too light, it blocks the view of the barn's side.

The mid-ground area is too colourful and distracting.

Finished painting

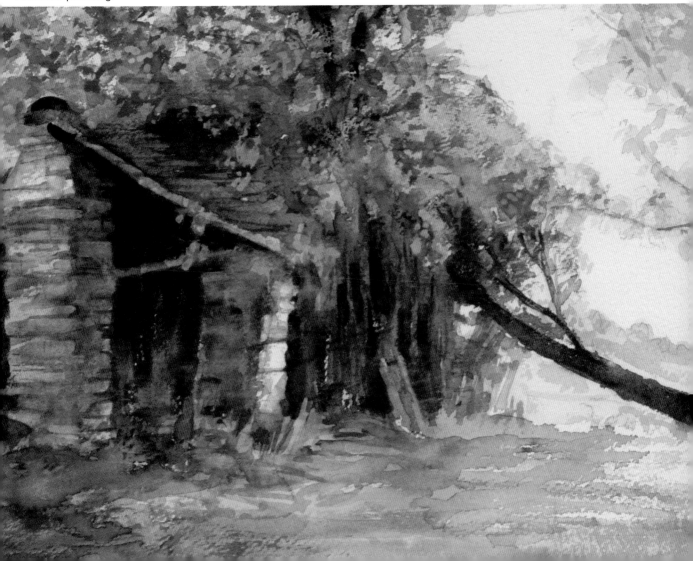

Gallery

Subtle paintings can be created by limiting the number of colours used and incorporating a variety of tones to create pattern and highlight interest.

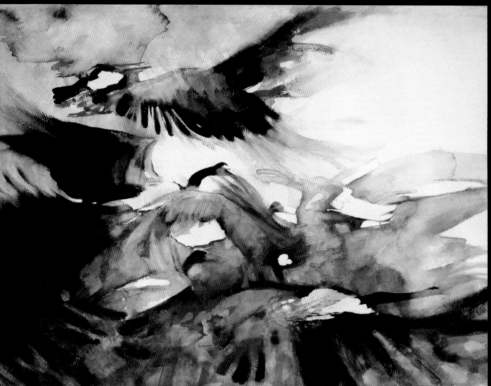

◄ Canada geese

The overall tone of this painting groups the birds together. The detail of the geese and their flapping wings has then been created through tonal contrast. A limted use of bright colours adds areas of interest. *Glynis Barnes-Mellish*

▼ Sprouted brussels

This painting makes use of a limited blue-green palette and harmonious soft, yellow neutrals. The subtlety of the mid-tone range draws the eye to the delicate details and areas of focus. *Antonia Enthoven*

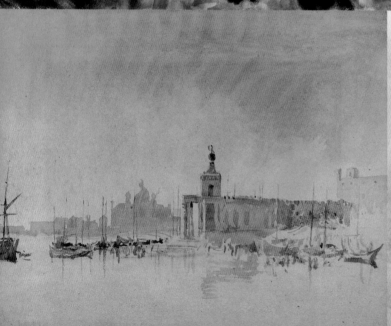

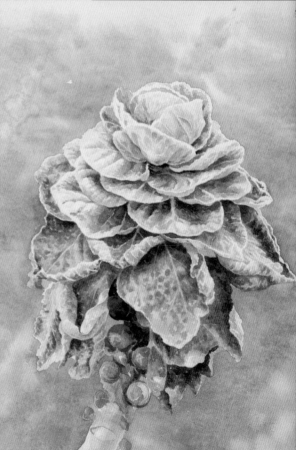

▲ Venice, Punta della Salute

This harmonious painting makes very effective use of a limited palette of colours that are all close to one another on the colour wheel. A subtle use of tone gives the painting structure, and the tonal contrast of the boats on the left leads the eye into the distance. *J.M.W. Turner*

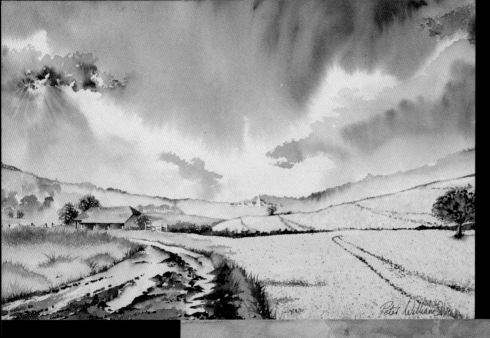

◄ Between the showers

The sky is the main area of interest in this picture and is painted a muted blue to suggest rain. If bright colours were used elsewhere they would vie for attention, so the tones used for the land have been deliberately held back. *Peter Williams*

Startled ►

Colour and tonal range have been limited in this painting. The use of pure colour and contrasting dark tones on the hat and coat of the young woman helps to focus attention on her. *Winslow Homer*

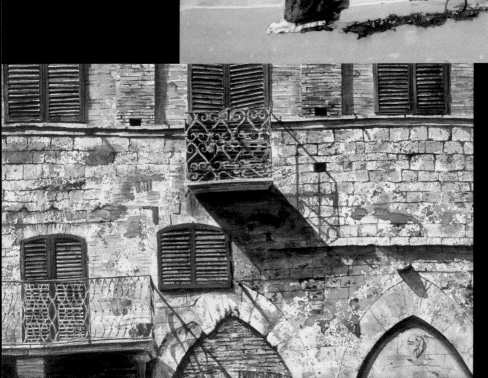

◄ Wall, Siena

A limited palette has been used here to control the area of interest. The contrast of the small amount of red with the unifying blues makes the window the clear focus. *Nick Hebditch*

4 Geese in the park

The setting for this painting is a hot summer's day with brilliant back lighting. To help create this effect, the whites and palest tones are preserved by slowly building up layers of colour around them. A limited palette is used, with yellow as the dominant colour. While this is mixed with other colours in the yellow-green background, the yellow and orange of the chicks are carefully layered, to keep them clean and bright. The muted blues and violets used to define the geese help to emphasize the bright, warm colours used in the rest of the painting.

EQUIPMENT

- Cold-pressed paper
- Brushes: No. 5, No. 9, 25mm (1in) flat
- Cadmium yellow, cerulean blue, Windsor violet, cadmium orange, burnt sienna, cadmium red, emerald green, French ultramarine, burnt umber, alizarin crimson

TECHNIQUES

- Layering
- Wet-in-wet

TRYING OUT COLOURS

A colour test sheet is a good way to plan which colours to use. Trying out strokes and blocks of different colours will give you a good idea of what they will look like when they are mixed together wet-in-wet on the paper rather than on your palette.

"Layering keeps colours pure and vibrant."

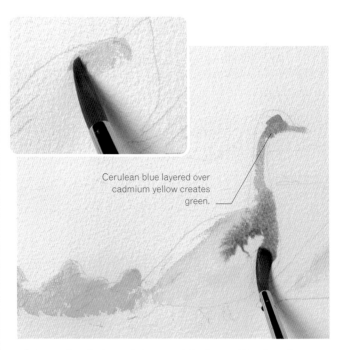

Cerulean blue layered over cadmium yellow creates green.

1 Paint the chicks and the geese's bodies and heads cadmium yellow, using the No. 9 brush. Then paint the geese's heads and necks cerulean blue and their chests Windsor violet.

BUILDING THE IMAGE

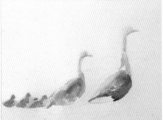
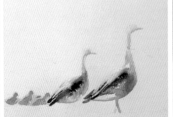
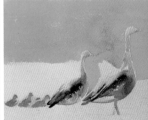

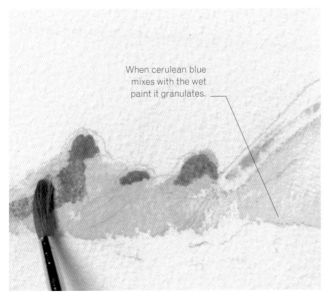

When cerulean blue mixes with the wet paint it granulates.

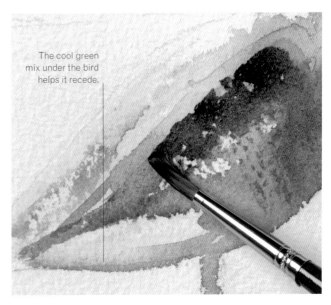

The cool green mix under the bird helps it recede.

2 Add cerulean blue to the lower parts of the geese to create cool shadows. When the paint on the chicks has dried, add dashes of cadmium orange to their heads and cerulean blue to their bodies.

3 Build up more layers of colour on the geese, using cerulean blue, Windsor violet, burnt sienna, cadmium red, and cadmium yellow. Finish by using a mix of burnt sienna and Windsor violet to paint the wing feathers.

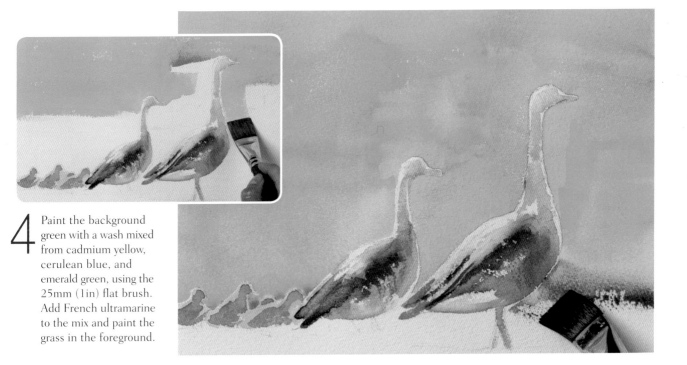

4 Paint the background green with a wash mixed from cadmium yellow, cerulean blue, and emerald green, using the 25mm (1in) flat brush. Add French ultramarine to the mix and paint the grass in the foreground.

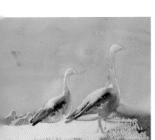
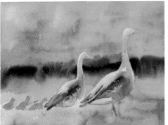
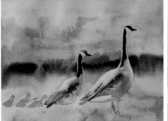
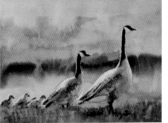

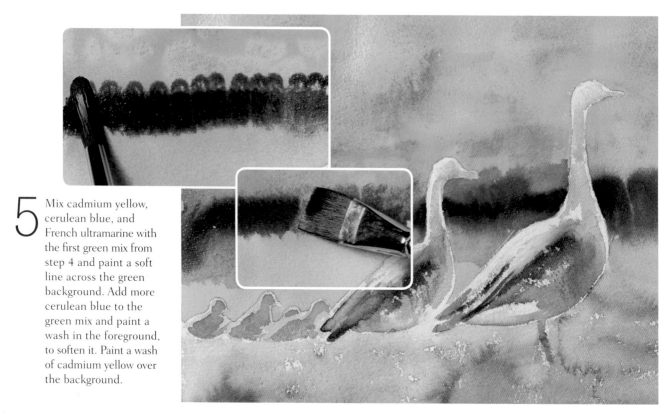

5 Mix cadmium yellow, cerulean blue, and French ultramarine with the first green mix from step 4 and paint a soft line across the green background. Add more cerulean blue to the green mix and paint a wash in the foreground, to soften it. Paint a wash of cadmium yellow over the background.

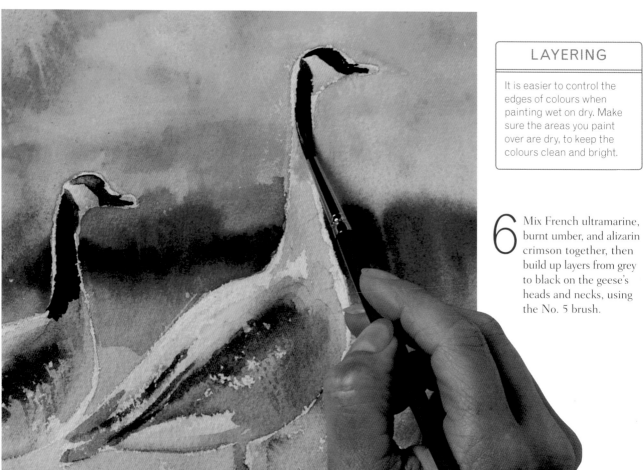

LAYERING

It is easier to control the edges of colours when painting wet on dry. Make sure the areas you paint over are dry, to keep the colours clean and bright.

6 Mix French ultramarine, burnt umber, and alizarin crimson together, then build up layers from grey to black on the geese's heads and necks, using the No. 5 brush.

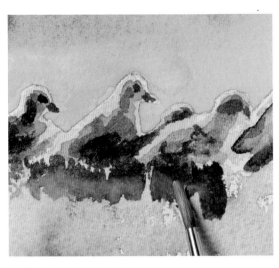

8 Soften the dark green with cadmium yellow. Use cerulean blue to tone down the white edges of the geese, add the geese's legs, and paint the shadows on the grass.

7 Add details to the chicks with cerulean blue and burnt umber. Paint lines of dark green and yellow below the birds to help anchor them firmly in place against the loose background.

▼ Geese in the park

The clean, sharp shapes and bright colours of the geese and chicks have been created by building up layers of paint. The neutral tones convey the softness of the geese's feathers and the use of contrasting bright colour brings the chicks into focus.

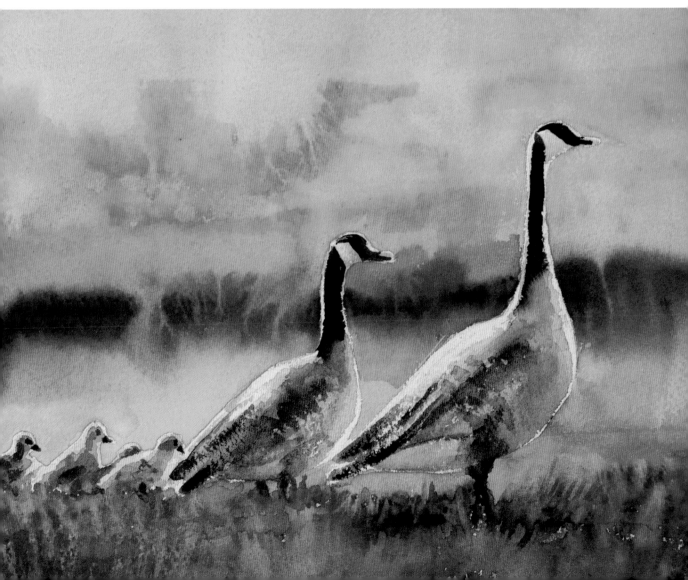

⑤ Peony in a jar

A single flower can be an absorbing and rewarding subject to paint, and gives you the chance to study one thing in detail. Much of the peony in this painting is in shade, which gives you a certain amount of free rein when painting the colours. Lifting out lines of colour to create details in the areas of shadow creates soft, light marks rather than stark, white highlights. This subtle treatment of the leaf and stamens provides a strong visual contrast to the brightly lit, sharp edges of the petals, which sparkle with vibrant colour.

EQUIPMENT

- Cold-pressed paper
- Brushes: No. 5, No. 9, 25mm (1in) flat
- Raw sienna, alizarin crimson, permanent mauve, cadmium red, emerald green, cerulean blue, French ultramarine, burnt sienna, burnt umber

TECHNIQUES

- Lifting out
- Painting glass

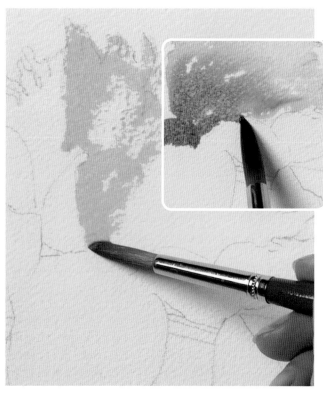

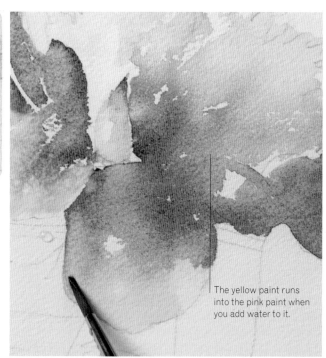

The yellow paint runs into the pink paint when you add water to it.

1 Paint the centre of the flower in raw sienna with the No. 9 brush. Mix pink from alizarin crimson and permanent mauve, then paint the petals pink while the raw sienna is still wet, so that the pink and yellow paint run together.

2 Rinse your paintbrush then use it to brush clean water along the edges of some of the petals, to soften the pink and create highlights. Adding water to the yellow paint makes it run into the pink paint.

BUILDING THE IMAGE

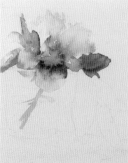
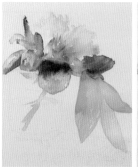
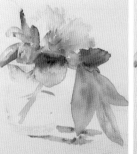
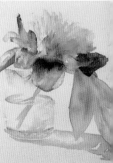

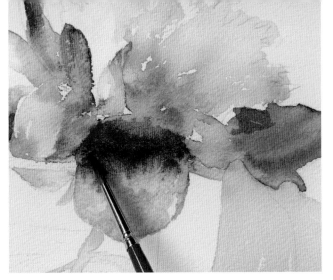

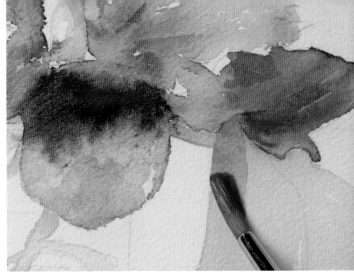

3 Paint the stem and leaves with raw sienna. Add permanent mauve and alizarin crimson to the petals while they are still wet. Soften some areas with a clean brush to vary the tones.

4 Add cadmium red to the petals and the tips of the stamens. Mix raw sienna and permanent mauve to create a neutral tone for the stamens and paint the leaves emerald green.

5 Mix grey from cerulean blue, pink, and raw sienna and paint the top of the glass. Use cerulean blue to paint the lines of shadow next to the glass.

6 Add raw sienna to the shadows and green to the flower stem. Paint strokes of cerulean blue to create the effect of bubbles inside the glass.

7 Mix cerulean blue and permanent mauve together to make a neutral colour. Use this to paint the shadow around the bottom of the glass.

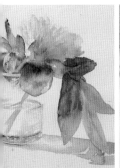
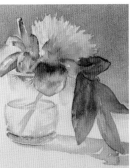
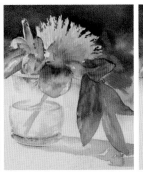
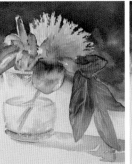
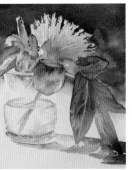

Lifting out removes the top layer of paint and reveals the layer of colour beneath it.

8 Paint the surface of the water in the glass with raw sienna. Draw a clean, wet flat brush across the flower stem to lift out some of the green paint and show how the water distorts the stem.

9 Strengthen the colour of the petals with pure alizarin crimson and permanent mauve. Mix emerald green and French ultramarine together to make a darker green and use this to paint the tops of the leaves.

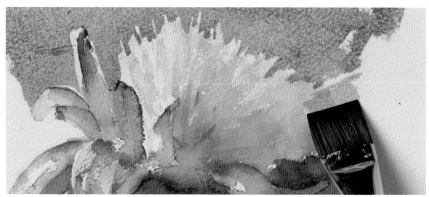

10 Mix cerulean blue and burnt sienna together. Paint a light wash behind the flower with the 25mm (1in) flat brush and soften the edges with a little water.

11 Mix French ultramarine and burnt umber and paint it over the background wash while still wet. Use a No. 5 brush to draw the colour down between the stamens.

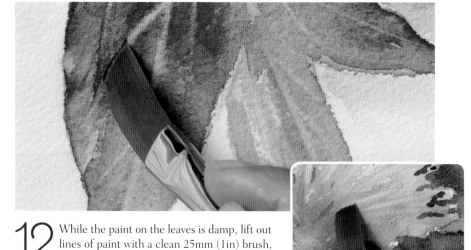

12 While the paint on the leaves is damp, lift out lines of paint with a clean 25mm (1in) brush, to create the veins of the leaves. Lift lines of paint from the leaf stem in the same way. Add dark green to the tip of the lower leaf.

LIFTING OUT

Be careful not to use too much pressure when lifting out. Use a clean, damp brush and blot the paper between lifting strokes.

Peony in a jar ▶

Removing paint by lifting out colour has been used as an effective technique here to add detail both to the flower stem and the leaves. The veins of the leaves are soft, in direct contrast to the sharp edges of the flower's petals and stamens.

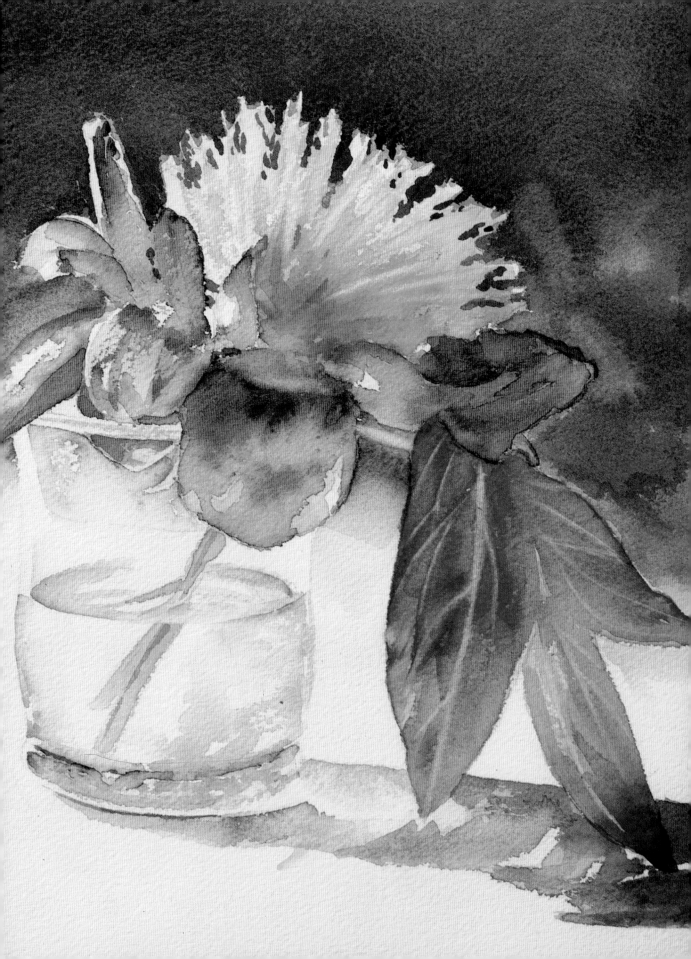

6 Boats on the canal

In this painting of two small boats on a Venetian canal, orange is both the dominant and the underlying colour. Because the first layer of orange paint shows through subsequent layers of colour in the reflections and shadows, it unifies the different elements of the picture. Lifting out colour with a clean damp brush reinstates light areas accidentally lost in the first few washes. This is particularly useful here, as the lighter tones created by lifting out are gently tinted rather than white, so do not detract from the layers of colour used to depict the boats.

EQUIPMENT

- Cold-pressed paper
- Brushes: No. 5, No. 9, 12.5mm (½in) and 25mm (1in) flat
- Raw sienna, cadmium yellow, light red, cadmium red, cerulean blue, burnt sienna, French ultramarine, Windsor violet, burnt umber, alizarin crimson

TECHNIQUES

- Creating shadows
- Lifting out
- Layering

The broken wash will help to reflect the colour of the brickwork.

1 Paint the brickwork and water with a raw sienna wash. Make vertical strokes with the 25mm (1in) flat brush, letting the wash break in places. Brighten the brickwork with cadmium yellow, then add vertical stokes of light red and soften with water.

2 Mix cadmium red and cerulean blue to make grey for the stairs. Mix cerulean blue and yellow for the water, and paint the ripples on the water with the edge of the 25mm (1in) flat brush. Use cerulean blue to define the edges of the building.

BUILDING THE IMAGE

3 Paint the railings with cerulean blue and a mix of light red and cerulean blue. Add burnt sienna to the bricks. Use cerulean blue and burnt sienna for the steps and the dark water. Mix French ultramarine and light red for the alley and the low bricks next to the water. Tone down the white areas with raw sienna.

"Adding layers of complementary paint makes the colours look more muted."

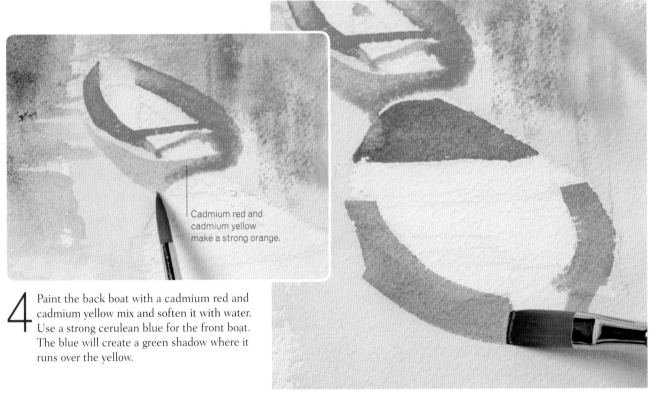

Cadmium red and cadmium yellow make a strong orange.

4 Paint the back boat with a cadmium red and cadmium yellow mix and soften it with water. Use a strong cerulean blue for the front boat. The blue will create a green shadow where it runs over the yellow.

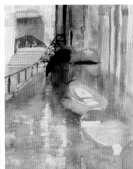
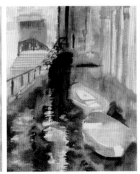
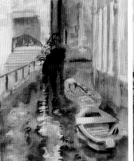
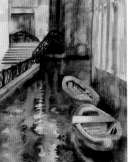

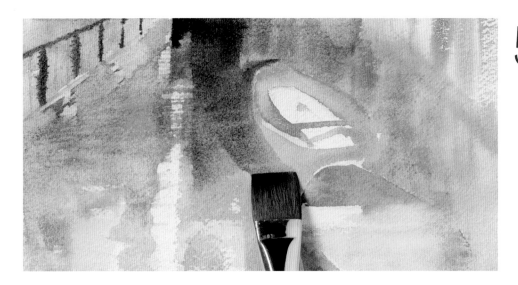

5 Paint the canal with vertical strokes of watery cerulean blue, using the 25mm (1in) flat brush. Use short lines rather than long strokes. Mix Windsor violet and burnt umber for the darkest parts of the water and to paint the area beneath the bridge. You do not need a green for the darker areas of the water.

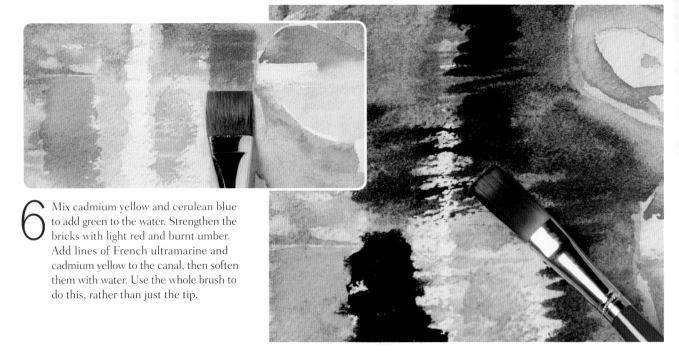

6 Mix cadmium yellow and cerulean blue to add green to the water. Strengthen the bricks with light red and burnt umber. Add lines of French ultramarine and cadmium yellow to the canal, then soften them with water. Use the whole brush to do this, rather than just the tip.

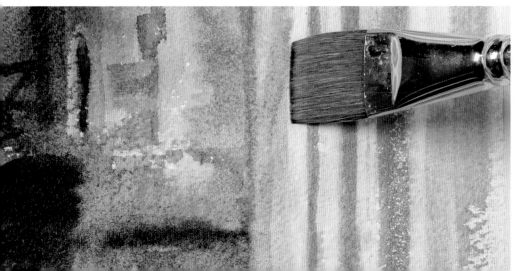

7 Darken the lower part of the building with the mix of Windsor violet and burnt umber. Using a clean, wet stubby brush, lift out narrow, vertical lines of colour from the walls to create the effect of windows.

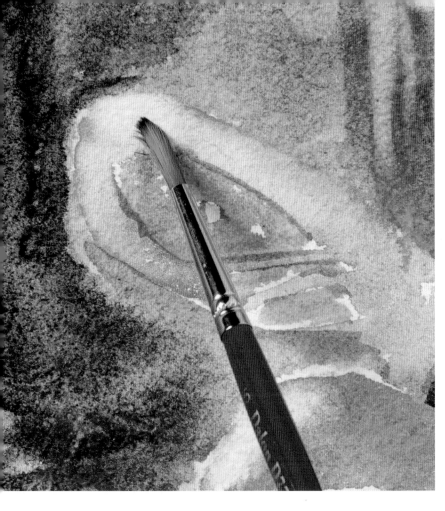

8 Paint shadows on the orange boat with French ultramarine and lift out some orange at the front of the boat to create a highlight. Paint details on the blue boat with a mix of cerulean blue and cadmium yellow. Use burnt umber for the shadows.

SHADOW COLOURS

Painting over a colour with its complementary colour, even if this colour is lighter, will create a neutral tone that you can use to paint shadows.

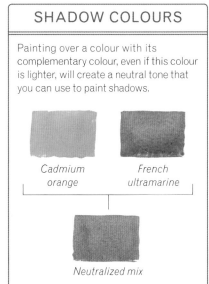

Cadmium orange *French ultramarine*

Neutralized mix

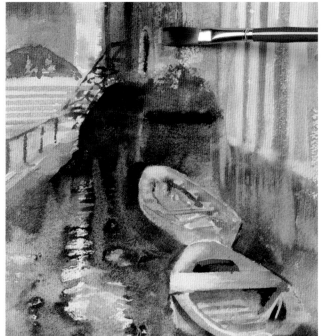

9 With the side of the 12.5mm (½in) brush, add detail to the bricks with burnt umber and paint Windsor violet over the green of the water. Paint the dark shadow beneath the blue boat with a mix of Windsor violet and burnt umber.

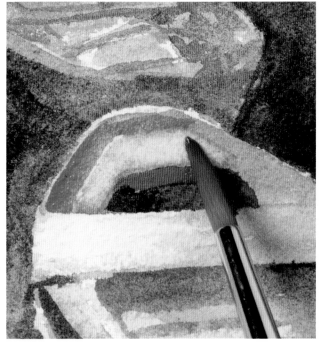

10 Paint a line of undiluted cerulean blue around the bow of the blue boat to strengthen the colour. Then lift out some of the blue with a clean, wet brush to create the effect of shadows and highlights.

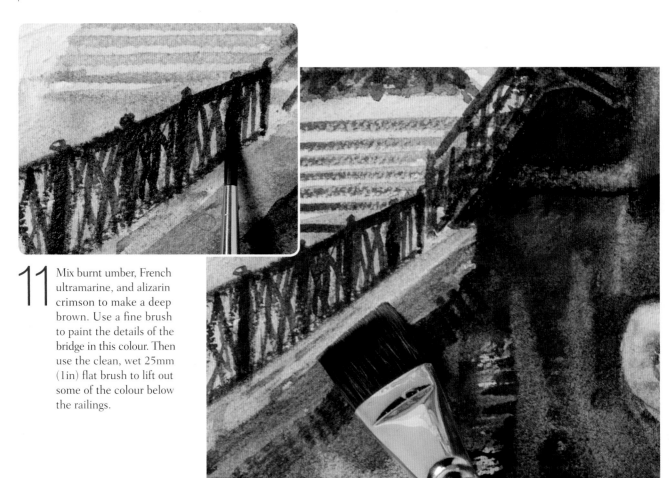

11 Mix burnt umber, French ultramarine, and alizarin crimson to make a deep brown. Use a fine brush to paint the details of the bridge in this colour. Then use the clean, wet 25mm (1in) flat brush to lift out some of the colour below the railings.

12 Add a mix of cadmium yellow and cadmium red to the orange boat to strengthen the colour. Paint details in dark brown then add a line of cerulean blue (a complementary colour) to create a shadow at the back of the boat.

Boats on the canal ▶

The eye is drawn into the finished painting by the vertical lines of the buildings and the reflections in the canal. The limited palette of neutral tones used in the water emphasizes the vibrant colour of the boats, making the composition stronger.

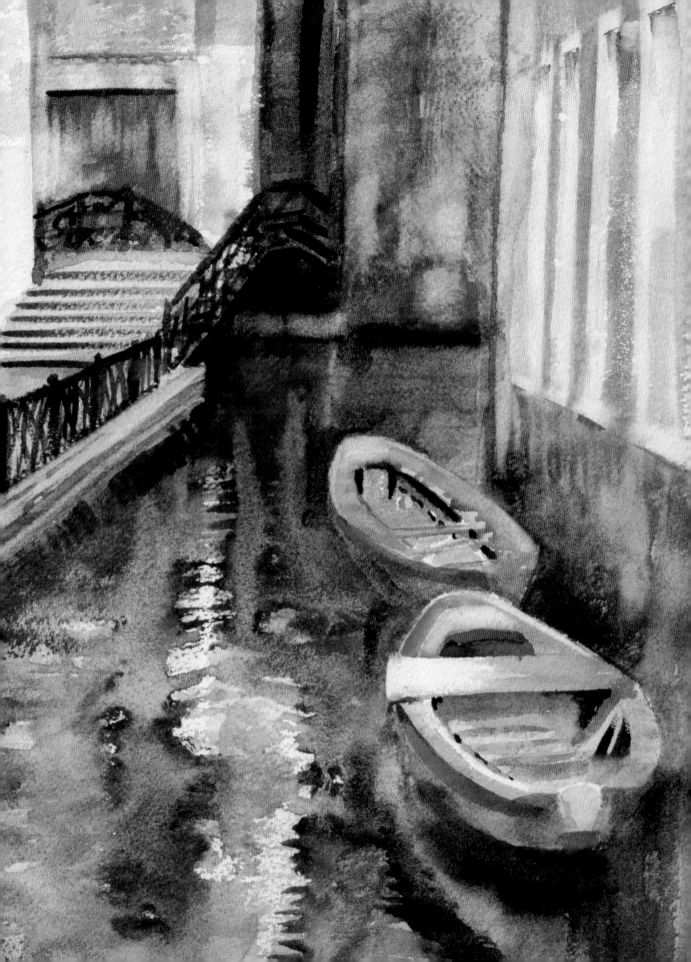

Perspective

"Red is in front,
blue is behind, and
green is in between."

Creating depth with colour

The colours of objects appear to change depending on how near or far they are from you, because of atmospheric conditions. In the foreground, colours are at their warmest and strongest and have the widest range of tones. With distance, colours lose their intensity, becoming bluer and lighter with less tonal variation. To create a sense of perspective in your paintings, forget what colour you think an object is and paint it the colour you actually see. This will be determined by how near or far away the object is.

RED COMES FORWARD

The coloured grid on the right shows how the warmth, or lack of warmth, of a colour affects where it sits in a painting. Warm colours such as reds and oranges appear to come forward, cool blue colours seem to recede, and greens sit in the middle distance.

By positioning warm and cool colours carefully, you can create a sense of depth in the scenes you paint. A simple landscape of green fields with red poppies in the foreground and a distant blue sky immediately has a sense of perspective. On a smaller scale, you can make individual objects look more solid if you paint the part of the object closest to you with warm colours and use cooler colours on the sides of the object, as these are further away from you.

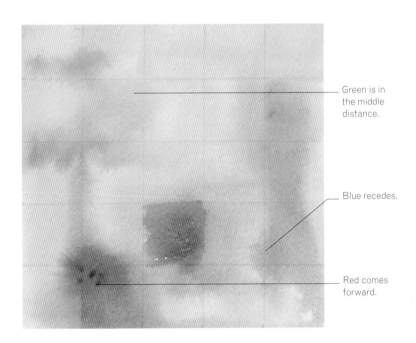

Green is in the middle distance.

Blue recedes.

Red comes forward.

WARM AND COOL PALETTES

Paints are described as warm or cool depending on whether they have a reddish or bluish tone. This varies according to the pigment used to make them. A warm colour such as red, for example, can appear in the cool palette if the pigment used to make it has a bluish tone, as with alizarin crimson. Selecting colours from both palettes in your paintings will help you create perspective.

Warm colour palette

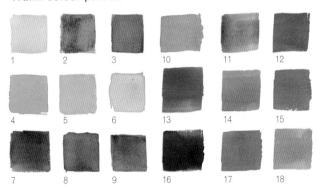

1. cadmium yellow 2. burnt sienna 3. cadmium red 4. emerald green 5. cadmium orange 6. raw sienna 7. burnt umber 8. sap green 9. French ultramarine 10–18. neutral mixes.

Cool colour palette

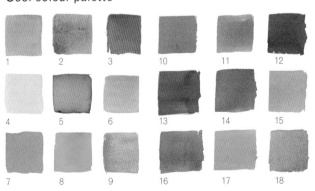

1. cobalt blue 2. raw umber 3. alizarin crimson 4. lemon yellow 5. Windsor violet 6. yellow ochre 7. permanent mauve 8. viridian 9. cerulean blue 10–18. neutral mixes.

CREATING DEPTH

All paintings, regardless of subject matter, rely on the use of warm and cool colours to create a sense of depth. By understanding how distance and atmosphere change colours and tones you can control the sense of depth in your paintings.

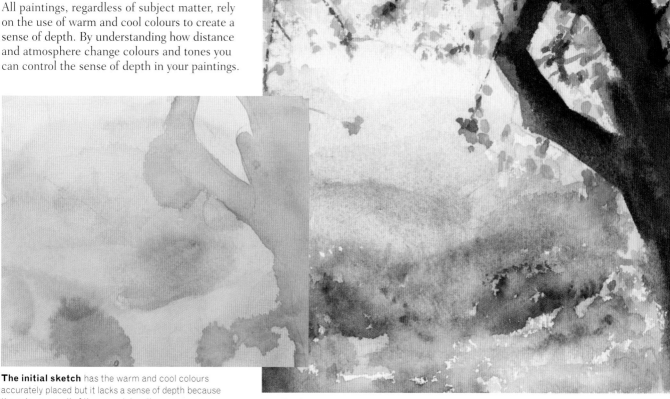

The initial sketch has the warm and cool colours accurately placed but it lacks a sense of depth because the colours are all of the same intensity.

The final painting has the colours carefully positioned and decreasing in intensity towards the horizon, so has a sense of depth.

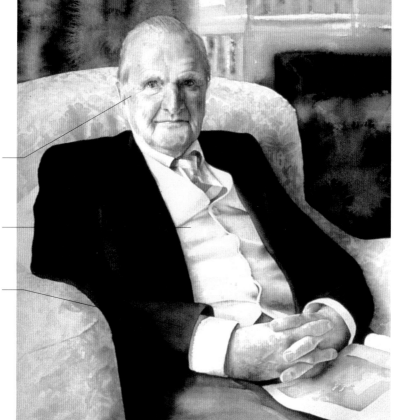

The use of warm and cool colours on the face helps to make it look three-dimensional.

The warm colour of the waistcoat comes forward to give bulk to the figure.

Warm tones in the jacket complement the skin tones.

In this portrait colours have been chosen from both the warm and cool palette. The waistcoat, for example, is a warm yellow but the background yellows are cool. It is this careful use of colour that creates the sense of depth.

Gallery

A sense of perspective can be created in paintings by using warm, strong colours in the foreground and cool, pale colours for more distant objects.

▲ West Dean poppies

This landscape has a real sense of depth due to its careful use of warm and cool colours. The trees become blue towards the horizon, while the foreground is painted with warm reds and yellows.
Sara Ward

Lobster pots at Beesands beach, Devon ▶

The focus in this painting is firmly on the strong red and hot orange boxes in the foreground. Greens in the foliage and neutral baskets hold the middle distance, and the blue at the horizon gives depth.
Robert O'Rorke

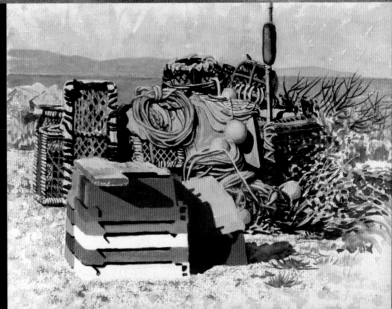

◀ Red poppies

This simple study shows how even in close-up subjects warm and cool colours can be used to create depth. Here the reds of the petals and warmer greens come foward, while the background is pushed back with a blue wash. *Glynis Barnes-Mellish*

▼ Young girl

This painting is quite abstract but its use of warm and cool colours gives it form. The hot colour in the centre of the face brings it forward, while the sides of the face and hair are cooler so they appear to recede. *Glynis Barnes-Mellish*

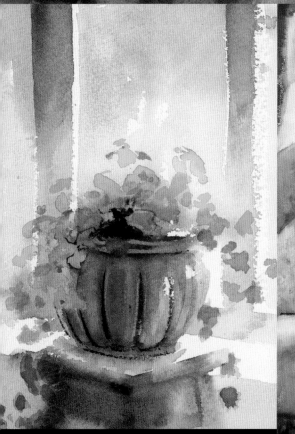

▲ Ivy

The foliage and glazed pot in this painting are both green but a sense of depth has still been created because a range of greens from warm to cool has been used. *Glynis Barnes-Mellish*

7 Field gate

A characterful old farm gate, made from rough, weathered wood, is the focal point of this painting. Using soft, loose washes of warm and cool colours for the surroundings sets the gate in its environment without creating any distracting detail. The gate itself is then painted using the dry brushwork technique, which is perfect for building up texture and conveying the rugged nature of the wood. Using rough paper breaks up the brushmarks and adds to the textural quality of the gate, as well as letting glimpses of the underpainting show through.

EQUIPMENT
- Rough paper
- Brushes: No. 9, No. 14, 12.5mm (½in) and 25mm (1in) flat
- Cadmium yellow, emerald green, cerulean blue, French ultramarine, burnt sienna, cadmium red

TECHNIQUES
- Dry brushwork
- Splattering
- Layering

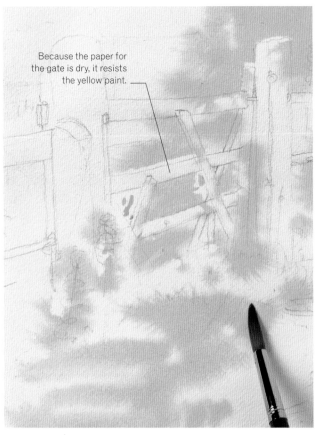

Because the paper for the gate is dry, it resists the yellow paint.

"Dry brushwork creates a textural effect."

1 Use a wide flat brush to wet the paper everywhere except for the gate itself, as you want it to remain white. While the paper is still damp, paint all the areas of grass and leaves cadmium yellow, using the No. 14 brush.

2 Mix a lime green from emerald green and cadmium yellow and use this to paint more foliage. Paint a wash of pure cerulean blue across the sky and the gate posts, using the 12.5mm (½in) flat brush.

BUILDING THE IMAGE

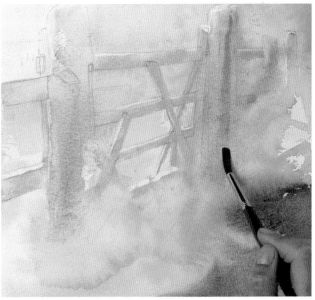

3 Mix French ultramarine and burnt sienna to create a warmer blue wash for the path and bring it into the foreground. Paint this colour on to slightly damp paper.

4 Add a line of burnt sienna to the edge of the road, to give it a little warmth. Using the same colour, drybrush the dry paper of the gate post.

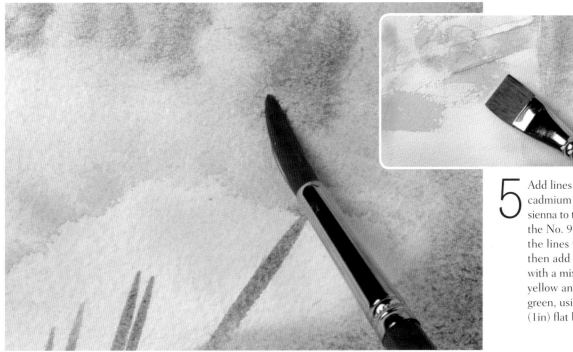

5 Add lines of a mix of cadmium red and burnt sienna to the foliage with the No. 9 brush. Soften the lines with water, then add more details with a mix of cadmium yellow and emerald green, using the 25mm (1in) flat brush.

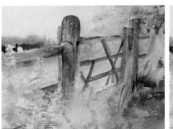
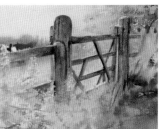

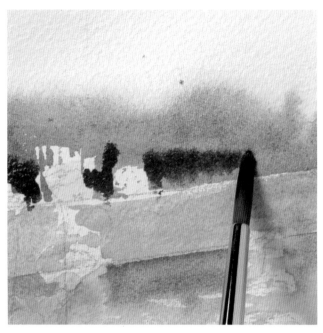

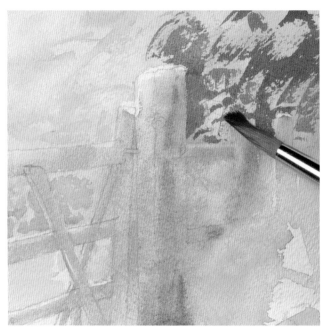

6 Paint water on to the area behind the gate with a clean brush, then add a mix of emerald green and French ultramarine with the No. 14 brush. Use the lime green mix below the post and soften it with water.

7 Drybrush more detail on to the leaves of the tree on the right with a mix of emerald green, cadmium yellow, and French ultramarine. Strengthen the colour of the background next to this tree with cadmium yellow.

8 Use the side of the 12.5mm (½in) flat brush to paint thin strokes of grass with a mix of French ultramarine, emerald green, and burnt sienna. Create flowers by adding cadmium red with the side of the No. 9 brush then flicking with water.

9 Start adding detail to the gate with dry brushwork. Use a light touch to make broken lines that suggest the texture of the wood. Use a variety of brown tones mixed from French ultramarine and burnt sienna.

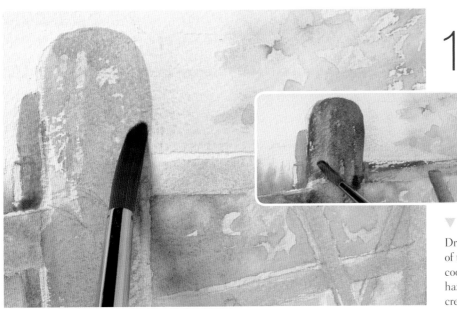

10 Model the shape of the gate post with cerulean blue. Add cadmium red to the front post to add warmth and make it appear to come forward. Add fine, dark details to the gate with a mix of burnt sienna and cerulean blue, using the No. 9 brush.

▼ Field gate

Dry brushwork creates the rough texture of the gate, while the soft, loose washes of cool and warm colour around it convey the hazy warmth of the afternoon sun and create a sense of depth.

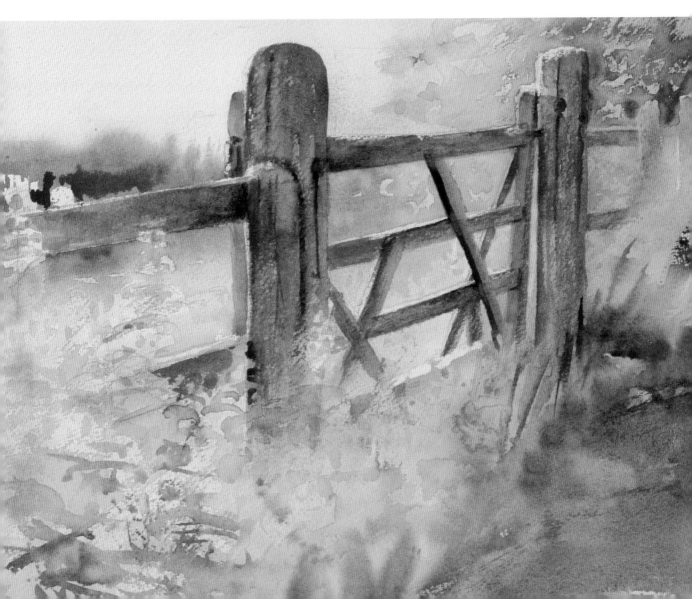

8 Wild hare

The hare in this painting almost fills the picture so that little design space is given to the field behind it, but creating perspective is just as important in close-up studies like this as it is in large landscapes. Using warm and cool colours to paint the hare creates a sense of depth and establishes the personality of the subject, from its quivering nose to its silky ears. Dry brushwork, softened with water, is very useful for painting animals, as it conveys the texture of their coats. Here it captures the essence of the hare's velvety fur.

EQUIPMENT

- Rough paper
- Brushes: No. 5, No. 9, No.14, 12.5mm (½in) flat
- Cerulean blue, alizarin crimson, raw sienna, burnt umber, French ultramarine, Windsor violet, burnt sienna, sap green, cadmium orange, cadmium yellow

TECHNIQUES

- Dry brushwork
- Underpainting

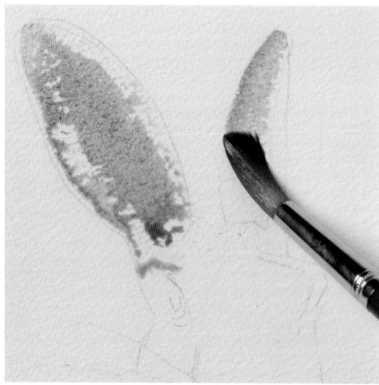

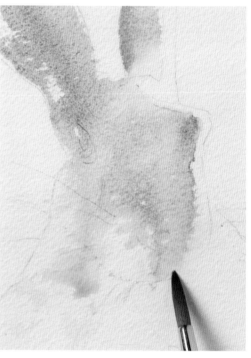

1 Paint the outsides of the hare's ears cerulean blue with the No. 14 brush, then use a mix of alizarin crimson and raw sienna to paint the insides of the ears. With a clean brush, run water down at the bottom of the ears to keep them soft.

2 Paint the front of the hare's face with raw sienna and use the cooler alizarin crimson for the sides. Apply the paint lightly so that the edges of the colours are jagged.

BUILDING THE IMAGE

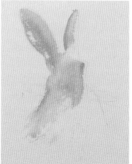
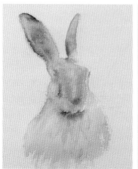
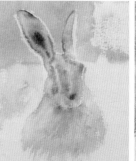
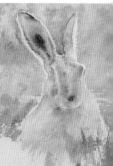

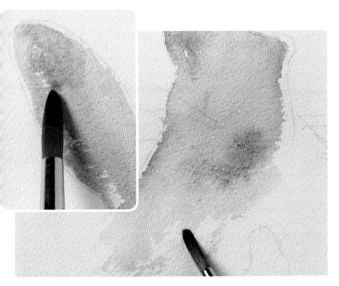

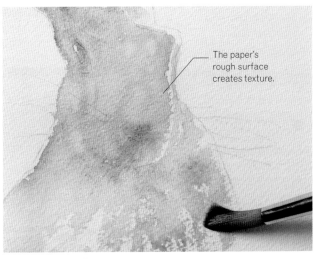

The paper's rough surface creates texture.

3 Add raw sienna while the cerulean blue paint on the ears is still wet, then paint the nose with a mix of alizarin crimson and raw sienna, using the No. 5 brush. Paint a little pure alizarin crimson below the nose.

4 Add cerulean blue to the raw sienna at the side of the face to create soft areas of green. Use water to push the paint away to look like fur. Drybrush a mix of raw sienna and alizarin crimson over the dry paper for the hare's body.

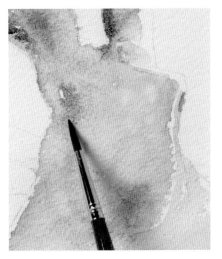

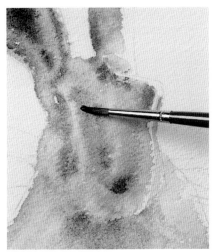

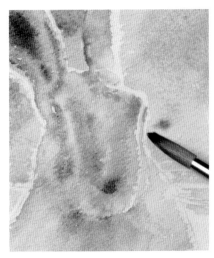

5 Mix burnt umber, French ultramarine, and Windsor violet together to paint shadows on the ears. Use cerulean blue to add the detail of the eye and the shadows under the hare's face.

6 Darken the face with a mix of burnt sienna and cerulean blue. Use a mix of burnt umber and alizarin crimson for the face and ears and Windsor violet for the tip of the nose. Drop in water to help create the fur texture.

7 Add a cool green made from cerulean blue and raw sienna to the background. While this is wet, add dashes of cerulean blue so that it granulates. Brighten the wash with a touch of raw sienna.

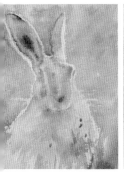
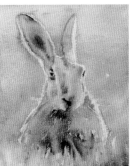
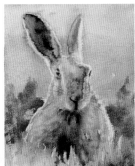
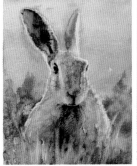

8 Warm up the green at the front of the picture with a mix of French ultramarine and cadmium yellow. Drybrush the colour on using the No. 14 brush.

CREATING A SENSE OF DEPTH

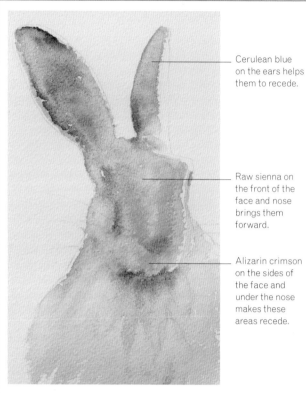

Cerulean blue on the ears helps them to recede.

Raw sienna on the front of the face and nose brings them forward.

Alizarin crimson on the sides of the face and under the nose makes these areas recede.

The head is given aerial perspective by keeping warm colours, which come forward, in the centre of the face, and cool colours, which recede, at the sides. More paint is drybrushed on top, but the initial colours still show through to retain the sense of form.

9 While the foreground is still wet, add touches of detail with alizarin crimson, raw sienna, and a mix of sap green and raw sienna. Leave parts of the paper white, to create the effect of sparkling highlights in the grass.

10 Mix Windor violet and burnt umber to paint around the hare's eye. Use the same colour to add the details of the nose, using water to soften them. Paint the shadows on the nose with cerulean blue.

11 Mix a warm dark brown from alizarin crimson, burnt umber, and Windsor violet and paint the fur with the No. 9 brush. Add cerulean blue to the mix and use this on the hare's sides and the dent on the side of its face.

12 Add the mix of burnt umber, alizarin crimson, and Windsor violet to the front of the face, and cadmium orange to the right-hand side. Add dashes of a mix of sap green and raw sienna to create the look of fur.

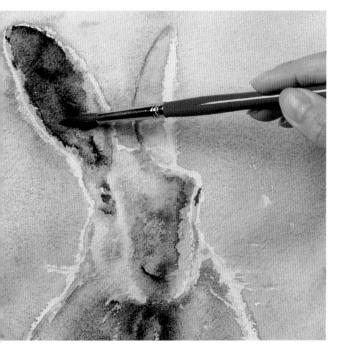

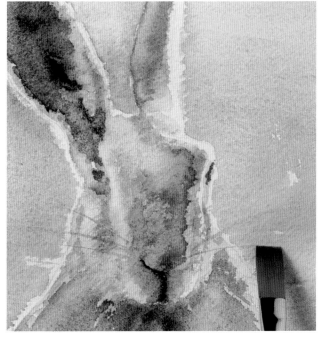

13 Darken the ears with a mix of burnt umber, Windsor violet, and a little alizarin crimson. Add French ultramarine and cerulean blue to this mix and use it to tone down the ears and add the shadow below the head.

14 Make the right ear darker with a mix of cerulean blue and Windsor violet. Use cerulean blue to mark the base of the whiskers. While the background wash is still wet, paint the whiskers with the 12.5mm (½in) flat brush.

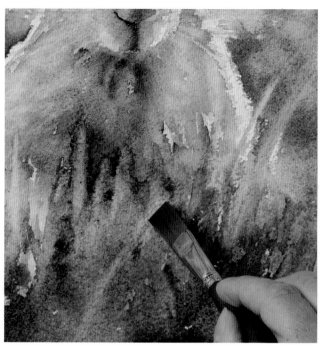

15 Use the side and point of the No. 14 brush to paint the dark grass sap green. Use a variety of strokes, making sure the brush is not overloaded with paint. Add alizarin crimson and raw sienna to the grass in the foreground.

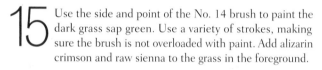

16 Drop a mix of alizarin crimson and raw sienna on to the grass while the paint is still wet, then use the clean, wet 12.5mm (½in) flat brush to lift out paint and create the long blades of grass in front of the hare.

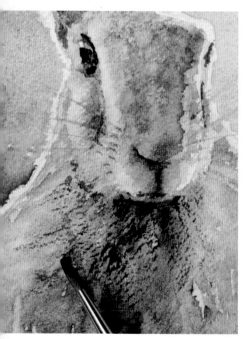

"Loose brush marks suggest movement and life."

18 Finish with some fine details on the face. Use a mix of burnt sienna and raw sienna on the right-hand side to bring it forward and add Windsor violet to the edge of the face.

17 Add strokes of burnt umber to the fur. Use a mix of burnt sienna and Windsor violet to paint the contours of the face and whiskers. Add cerulean blue to the side of the body and use a very dark brown mix to paint the eye.

Wild hare ▶

Using bright underpainting to create the hare's form and adding fine detail with dry brushwork have created a simple, yet effective study. Too much detail would have made the picture static.

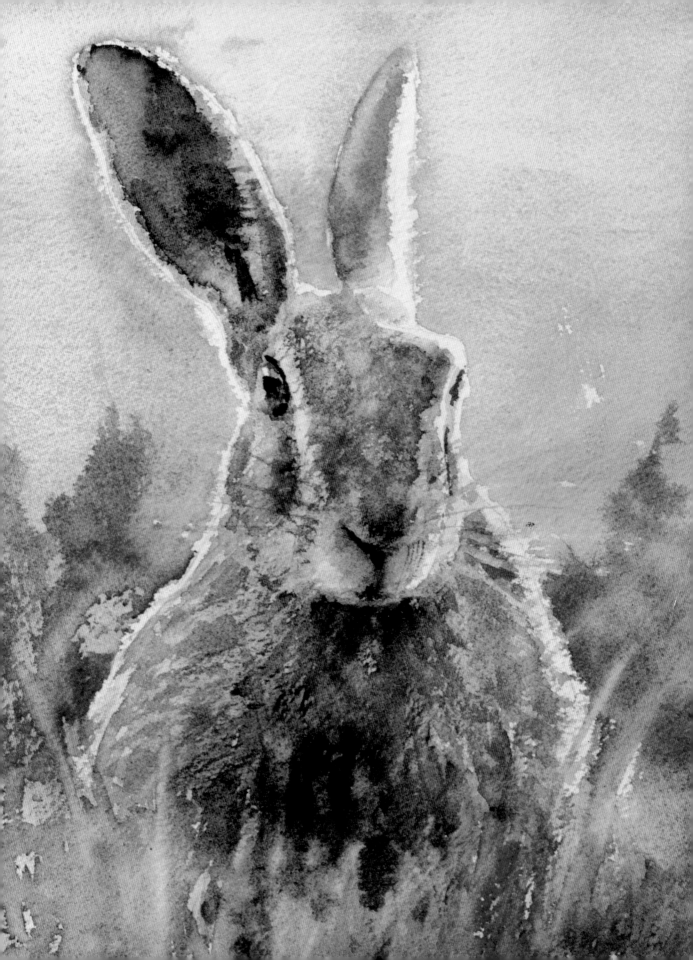

⑨ Street scene

Deserted street scenes can look a little uninteresting but by adding just a few people, a painting springs to life. Not only do figures add activity, they also create movement in a composition, leading the viewer's eye through the painting. In this scene the buildings are very tall and, due to the amount of shadow they cast, most of the interest is in the top half of the composition. Adding the figures at street level in the lower half of the painting emphasizes the scale of the buildings and helps to anchor them while introducing colour and interest.

EQUIPMENT

- Cold-pressed paper
- Brushes: No. 5, No. 9, 12.5mm (½in) and 25mm (1in) flat
- French ultramarine, cerulean blue, cadmium yellow, emerald green, raw sienna, Windsor violet, cadmium orange, raw umber, viridian, alizarin crimson, cadmium red, burnt sienna, sap green, burnt umber

TECHNIQUES

- Dry brushwork
- Adding figures

1 Using the 12.5mm (½in) flat brush, paint the sky with a graded wash, from French ultramarine at the top to cerulean blue at the bottom. Paint the trees cadmium yellow and let it dry, then drybrush emerald green and French ultramarine for the leaves.

2 Drybrush raw sienna for the buildings. Use a light wash of Windsor violet for the top of the building on the right. Use cadmium orange to paint the underside of the roof, then add fine lines of cerulean blue to create shadows.

BUILDING THE IMAGE

3 Add a mix of French ultramarine and cadmium yellow to the sky at the end of the street, to help the view recede into the distance. Sketch in the shapes of the figures in cerulean blue.

4 Using the 12.5mm (½in) flat brush, paint the shadows on the building and rooftop in Windsor violet. Add cadmium yellow for local colour and use a mix of cerulean blue and raw umber to paint the shadow under the roof.

5 Mix viridian and cerulean blue to make turquoise. Paint some of the shutters in this colour and use straight cerulean blue for others. Add French ultramarine to the detail at the far end of the street.

6 Add colour to the shadows by painting the undersides of the balconies in alizarin crimson with the No. 5 brush and then strengthen the colour with cadmium red.

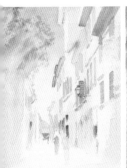
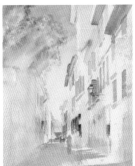
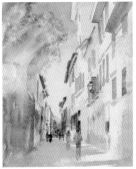
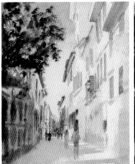
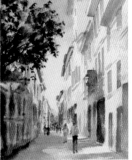

7 Paint the shadows under the windows with raw sienna. Use viridian for the open shutter. Paint the outline of the street lamp in burnt sienna and use the same colour to paint the arches on the building on the right.

"Use the simplest brushstrokes to convey human figures."

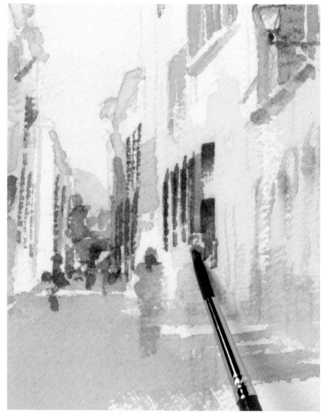

8 Mix burnt sienna, French ultramarine, and Windsor violet to make a deep purple for the shutters and the dark areas of the building on the right-hand side of the picture. Apply this mix with the 25mm (1in) flat brush.

9 Use a light wash of Windsor violet to paint the shadows on the street. Paint the faces of the figures with dots of cadmium red and strengthen the colour of their bodies with French ultramarine.

10 Paint a wash of cadmium orange on the lower half of the wall on the left. Use burnt sienna to paint the people in the distance, then mix burnt sienna and cerulean blue to add detail to the wall on the left.

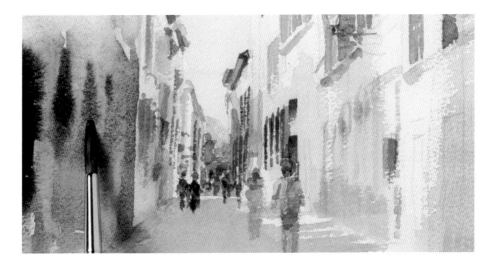

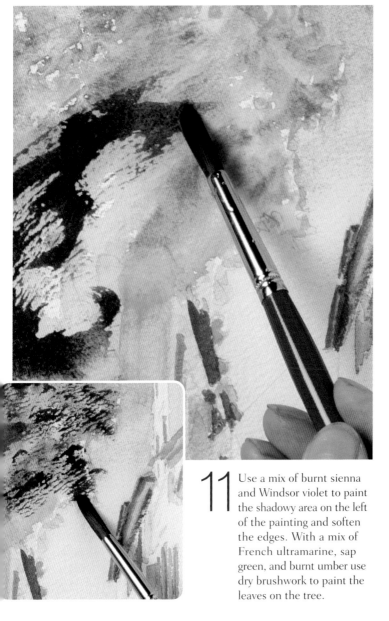

11 Use a mix of burnt sienna and Windsor violet to paint the shadowy area on the left of the painting and soften the edges. With a mix of French ultramarine, sap green, and burnt umber use dry brushwork to paint the leaves on the tree.

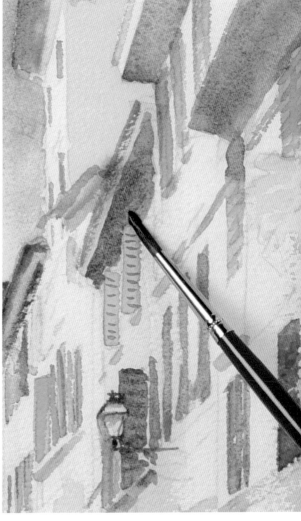

12 Mix burnt umber and Windsor violet, then paint the rooftops of the building on the right with the 12.5mm (½in) flat brush. Switch to the No. 5 brush and Windsor violet to add more detail to the building.

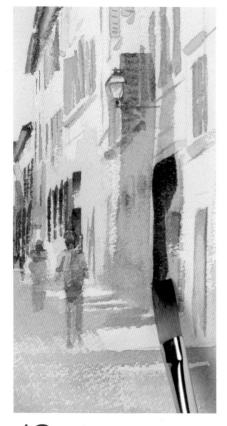

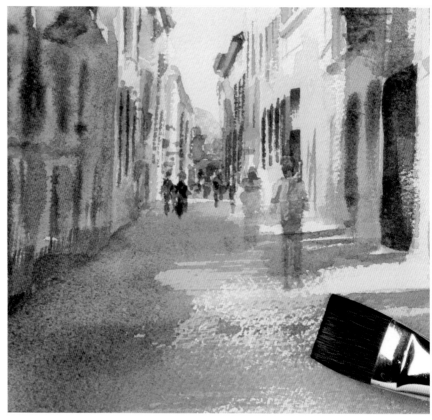

13 Mix burnt sienna and cerulean blue to make a warm neutral for the walls on the right. Add burnt umber for the darker shadows. Drybrush the mix of burnt sienna and cerulean blue on to the road to create shadows.

14 Paint a graded wash of French ultramarine on to the road, making it stronger in the foreground. While it is still wet, add burnt sienna and French ultramarine at the base of the building to create shadows.

PAINTING SHADOWS

Bright light creates light shadows as it spills into areas of shadow and fills them with pools of colour. Remember this when painting sunny scenes so that you don't make the mistake of painting shadows that are very dark and dull.

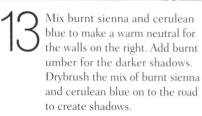

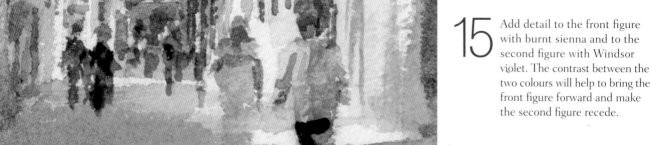

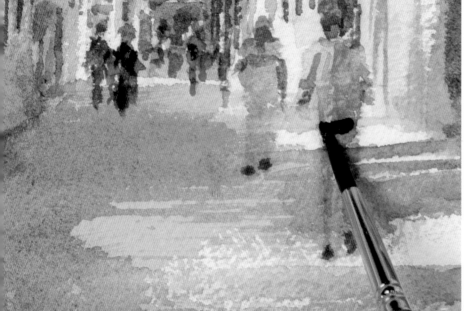

15 Add detail to the front figure with burnt sienna and to the second figure with Windsor violet. The contrast between the two colours will help to bring the front figure forward and make the second figure recede.

Street scene ▶

The painting has been kept loose to capture the liveliness of the scene. Giving the figures only the barest suggestion of form blends them into the landscape where they add more colour, and making the shadows light and colourful helps to create the sunny atmosphere.

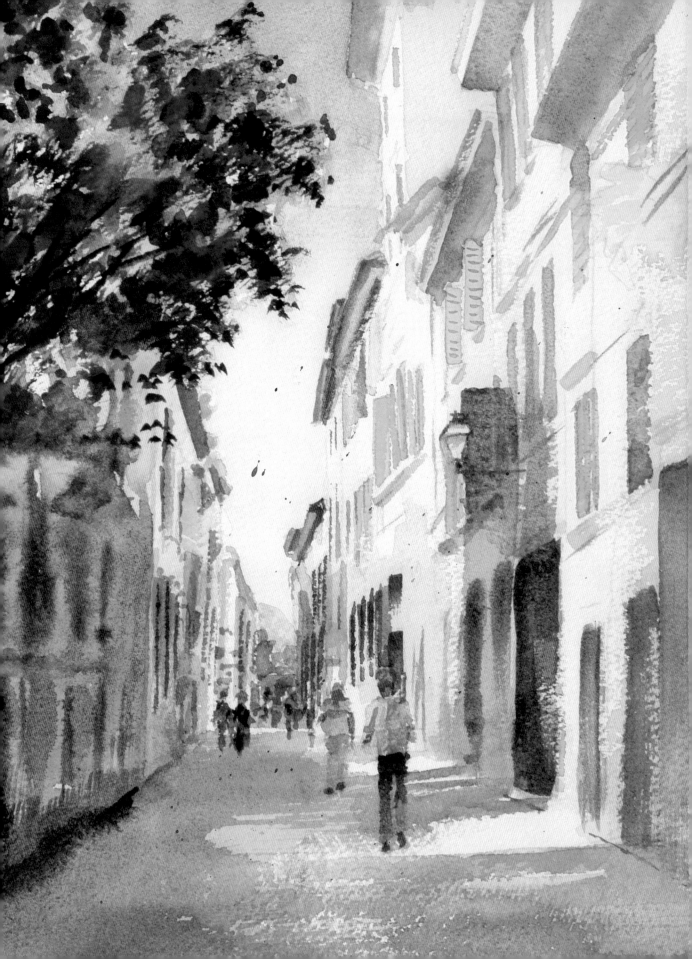

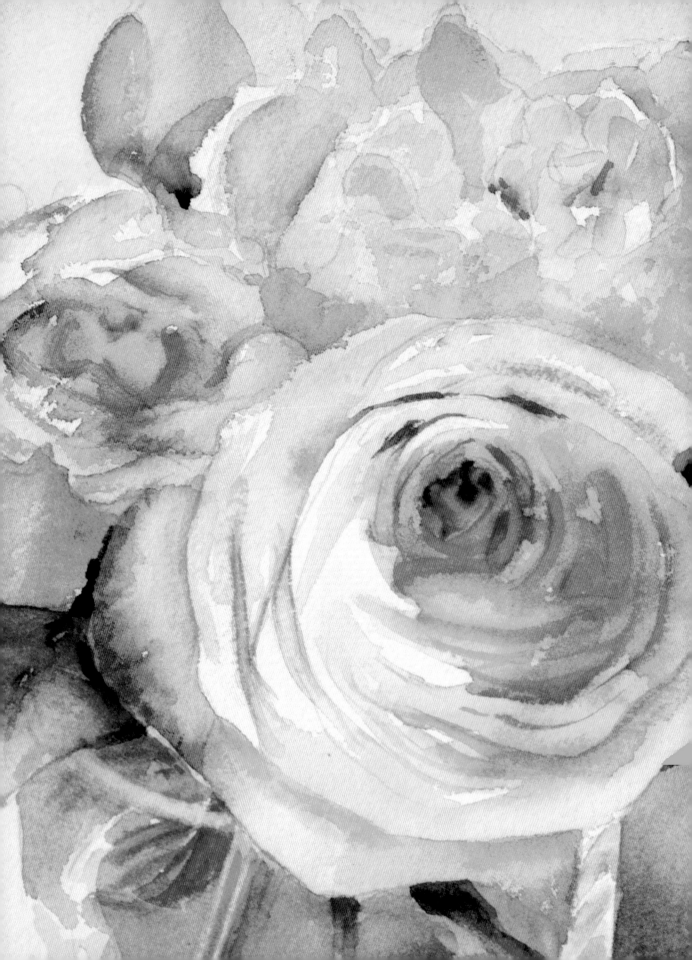

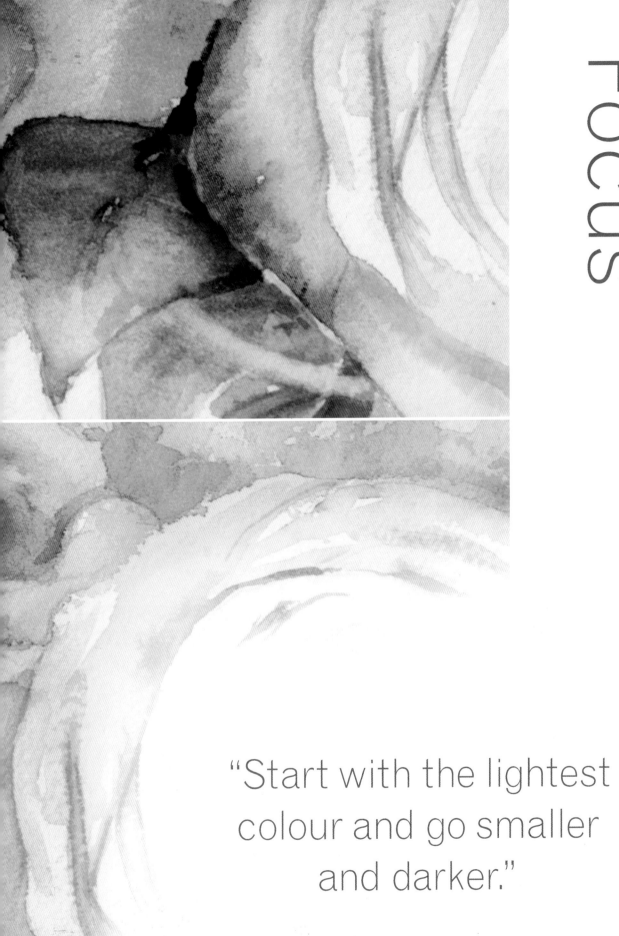

"Start with the lightest
colour and go smaller
and darker."

Focal point

A good painting has a strong focal point that immediately draws your eye to the main area of interest. The focal point of any image is the point where the lightest and darkest marks meet. You can use these tones elsewhere in your painting but they should only be next to each other where you want your viewer to focus. To emphasize the focal point even more, it is a good idea to restrict the range of tones you use for the details around it so that these areas are less defined and do not vie for attention.

LIGHT TO DARK

It is important to decide what your main point of interest is before you begin painting so that you can create a strong composition. Start by identifing the lightest colours in your composition. These colours lie underneath all the subsequent layers of colour, unifying your picture. Block in these large areas of colour first, then begin building up the mid tones to give your painting structure. Next paint smaller, darker details, and finally add tiny amounts of pure bright colour and the darkest tones of all to bring the main area of interest into focus.

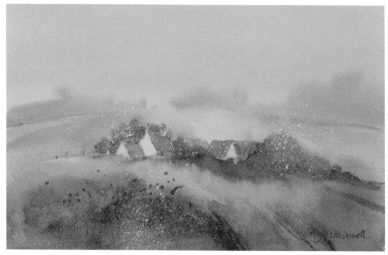

Farm buildings The buildings have been brought into focus in this picture as dark foliage has been painted next to their light stonework. Flicking a small amount of complementary red paint in the foreground creates further interest.

BUILDING LAYERS

This painting of a flowerpot has been built up in layers, starting with the lightest colours and then adding progressively smaller and darker areas of colour so that detail and focus are established.

Light tones

For this painting a mix of raw sienna and cadmium red was used first for the lightest tone.

Mid tones

The mid tones were then added. These create contrasts between objects and give them edges.

Dark tones

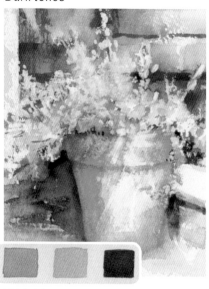

Mid dark details were painted, then dark accents added next to the lightest tones to create focus.

EMPHASIZING THE FOCAL POINT

The focal point of this painting of a gymnast is her legs and neck, and this is where the lightest and darkest marks have been placed next to each other. To emphasize this focal point, the distracting detail of the gymnasium has been replaced with a soft background wash. The gymnast's leotard merges into this wash, which also helps to keep attention on the legs.

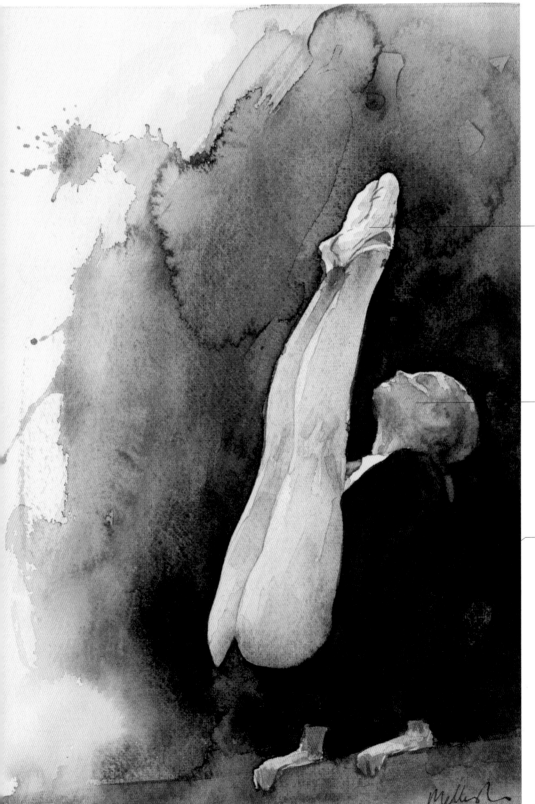

The lightest and darkest tones meet to focus attention on the feet.

The light areas on the face are set against mid tones to limit attention.

The body blends into the background to keep your focus on the legs.

Gymnast In this painting the lightest and darkest tones meet at the gymnast's neck and up through her legs and feet. Grouping many of the details together tonally helps to outline this focal point.

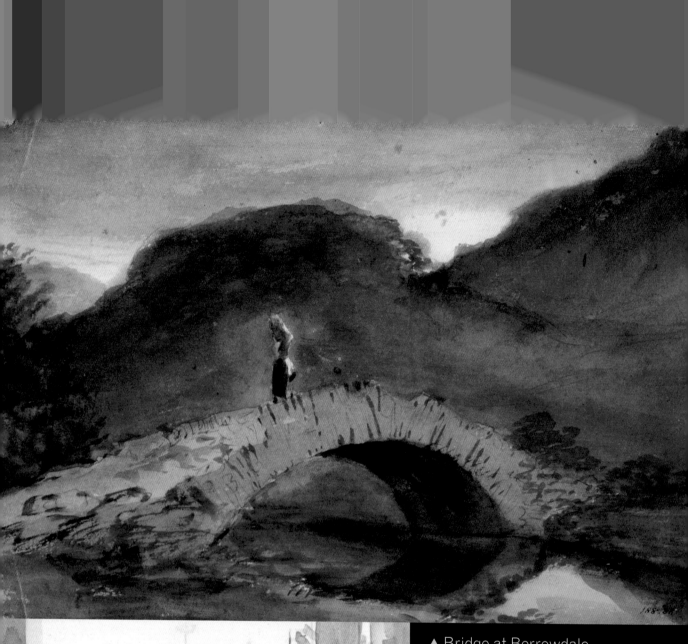

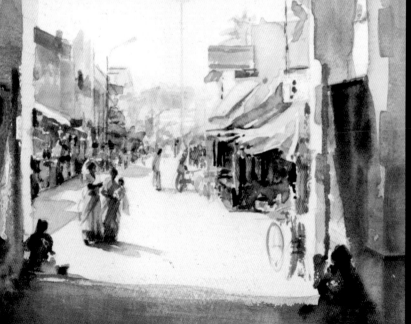

▲ Bridge at Borrowdale

The clear focal point in this muted painting is the figure standing on the bridge. This figure is the only place in the picture where the lightest and darkest tones meet. *John Constable*

Pink roses ▶

The deep central colour of the front rose and the lights and darks on the leaves either side of it, make this rose the focal point. The other blooms melt away without such contrast. *Glynis Barnes-Mellish*

◀ Street market

This busy steet scene contains a lot of detail, but by limiting the combination of light and dark to the two figures in yellow saris they remain the focal point. *Glynis Barnes-Mellish*

◀ A tramp

In this striking portrait the head of the man is set back in shadow while the foreground is quite light in tone. To focus attention on the face, the white shirt has been painted next to a very dark edge of the beard. *John Singer Sargent*

▲ Courtyard, Venice

In this painting the focus created by adjacent light and dark marks occurs in several different places, from the stone slab at the doorway, to the plant pot, to the back wall. This arrangement keeps the eye moving around the scene. *Nick Hebditch*

10 Chair by a window

Bright sunlight spilling on to the chair and floor animates this simple country interior. Resists are used to great advantage in this painting, as they keep parts of the paper white. This means that you can paint the first large areas freely and loosely, capturing the intensity of light coming through the window by using warmer colours closest to the source of light. Once the resists are removed, the contrast and tension between the darkest tones and the unpainted white paper focuses attention on the relationship between the chair and the window frame.

EQUIPMENT

- Cold-pressed paper
- Brushes: No. 5, 25mm (1in) and 12.5mm (½in) flat
- Raw sienna, burnt sienna, Windsor violet, cerulean blue, cadmium yellow, French ultramarine, cadmium red, titanium white acrylic paint
- Masking tape and masking fluid

TECHNIQUES

- Resist

RESISTS

Below you can see three different types of resist – masking tape, masking fluid, and wax candle – and the marks that they make on paper. Masking tape and fluid are used to protect areas that will be painted over once they have been removed. Masking fluid is more flexible in that you can create a more irregular shape with softer edges. Wax cannot be removed.

Paint over masking tape.

Masking tape removed.

Paint over masking fluid.

Masking fluid removed.

Applying wax.

Paint over wax.

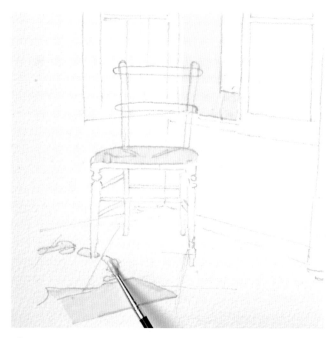

1 Put masking tape over the large areas of the picture that you want to keep white. Paint masking fluid on to the smaller areas. As the fluid is cream, you can see where it is. Use a cheap brush and clean it straightaway. Let the fluid dry completely.

BUILDING THE IMAGE

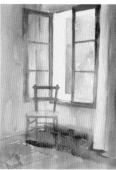

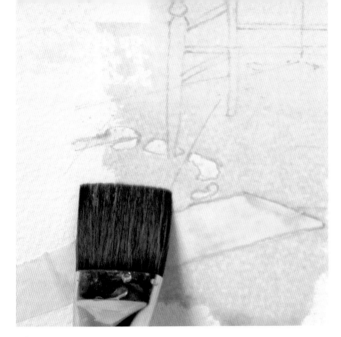

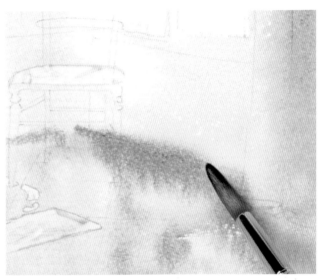

2 Paint the walls with a wash of raw sienna. You can do this freely without having to worry about the areas that will remain white. Paint the window frame raw sienna too.

3 While the paint is still wet, add a wash of burnt sienna to the curtain, the floor, and the wall beneath the window. Paint a line of Windsor violet around the edge of the floor.

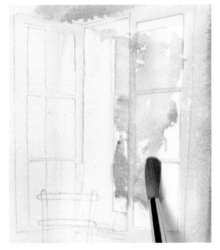

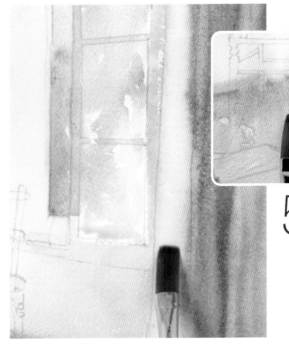

4 Use cerulean blue to paint the sky through the window. Add a little cadmium yellow to the lower part of the blue while it is still wet, to create a soft green for the trees outside the window.

5 Soften the edges of the curtains with a little water to suggest light falling on them. Use burnt sienna to add the details of the window frame and skirting board, then brush the paint down to create the effect of a sheen on the floor.

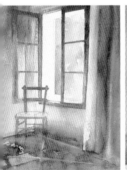
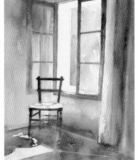
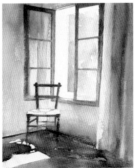
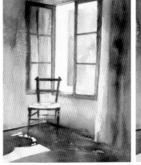
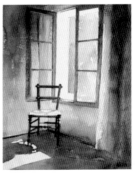

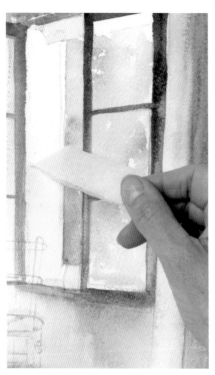

6 Strengthen the curtain's colour with burnt sienna and soften with a wet brush. Add raw sienna at the curtain's edge, then lift out some of the colour near the bottom of the curtain with a tissue, to show where the light falls.

7 Use the Windsor violet and burnt sienna mix to paint the second window frame, then remove the masking tape around the window. This will leave the outside walls, which are in sunlight, white.

8 Use a piece of paper to help you paint a fine straight line of raw sienna all the way along the edge of the open window. Using the paper helps to create a controlled line, which has a soft edge.

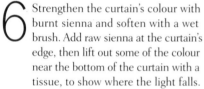

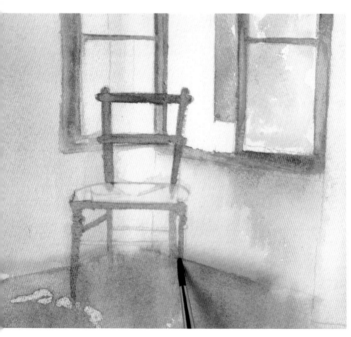

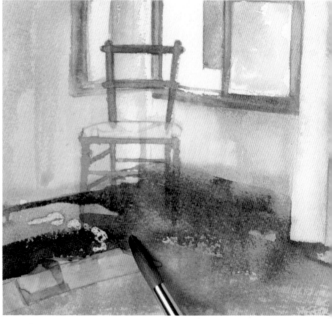

9 Use a mix of burnt sienna, French ultramarine, and Windsor violet to paint the chair back. Drybrush this mix on to the window frame to create a weathered texture. Paint the chair seat and legs with an orange mix of burnt and raw sienna.

10 Add cerulean blue to the orange mix for the shadow on the wall to the left. Mix burnt sienna and Windsor violet for the shadow on the floor and brush on raw sienna and burnt sienna to add texture and contrast.

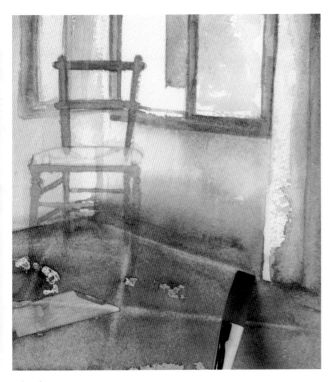

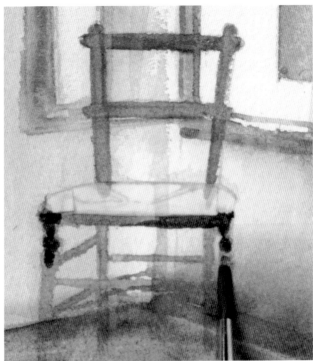

11 Paint the shadows on the wall with burnt sienna and Windsor violet. Keep the wall around the window orange so that it looks light. While the paint on the floor is still wet, lift out fine lines of colour to create interest.

12 Add further interest to the floor by flicking it with water to create backrun effects (*see p.30*). Darken the chair with French ultramarine and burnt sienna, then use Windsor violet to paint shadows on it.

13 Peel off the masking tape on the floor to reveal the white paper where there is a pool of light near the chair. Then, carefully peel away the masking fluid with your fingernails to leave patches of white paper where the light has been broken by the shadows of the chair.

MASKING FLUID

Always make sure that both the masking fluid and paint are completely dry before you remove the masking fluid so that you do not tear the paper.

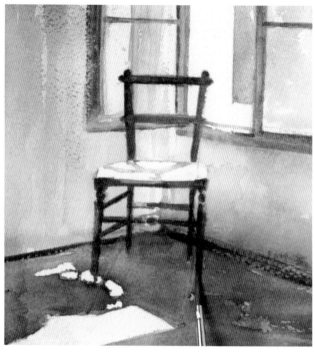

14 Use the Windsor violet and burnt sienna mix to darken the window frame and to paint the shadows of the chair legs. Add cadmium red to the corner for warmth and use Windsor violet for the shadow on the floor.

15 Darken the top of the picture with the burnt sienna and Windsor violet mix. Once the paint around the chair legs has dried, strengthen their colour with the burnt sienna and Windsor violet mix.

"Light can create interest in areas that are otherwise plain and empty."

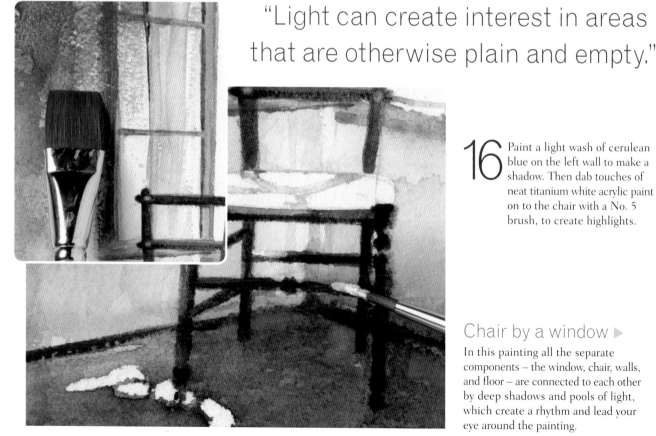

16 Paint a light wash of cerulean blue on the left wall to make a shadow. Then dab touches of neat titanium white acrylic paint on to the chair with a No. 5 brush, to create highlights.

Chair by a window ▶

In this painting all the separate components – the window, chair, walls, and floor – are connected to each other by deep shadows and pools of light, which create a rhythm and lead your eye around the painting.

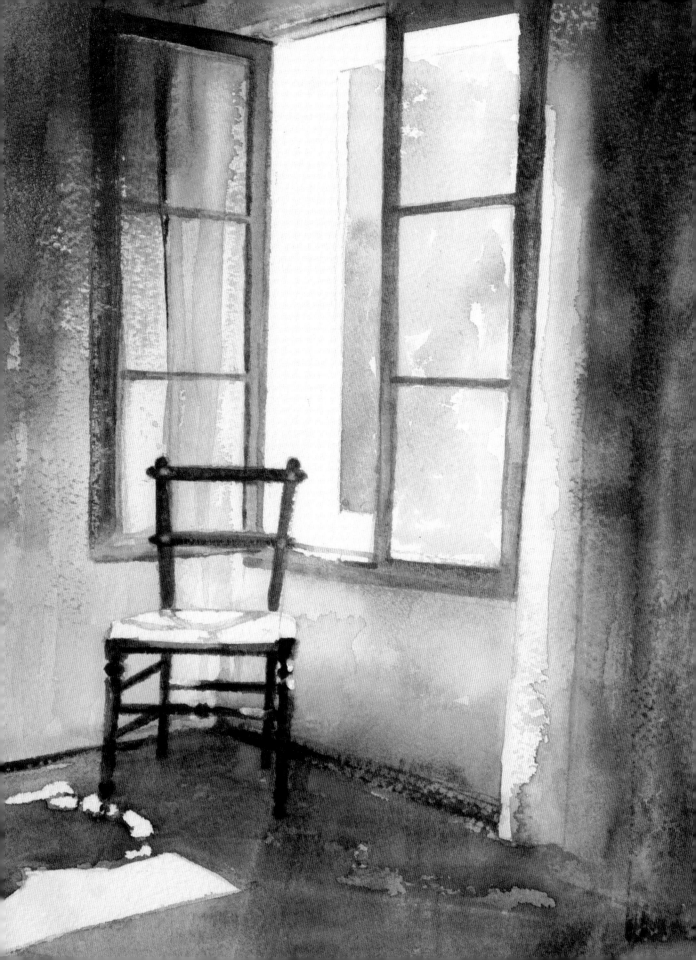

11 Cliffs and beach

This rugged and colourful seascape may look complex, but by identifying the underlying colours that unify the whole scene, it is easy to start work. The first washes create an interplay between the warm and cool colours, which establishes perspective and creates a sense of movement, vital in painting the sea. As you build up the subsequent layers of colour in the seascape, you can strengthen features and refine detail. Finally, using a razor blade to remove some of the paint from the sea produces broken marks that capture the effect of sunlight sparkling on the water.

EQUIPMENT
- Cold-pressed paper
- Brushes: No. 5, No. 14, 12.5mm (½in) and 25mm (1in) flat
- Razor blade
- Burnt sienna, cerulean blue, turquoise deep, Windsor violet, cadmium orange, cadmium yellow, emerald green, French ultramarine, alizarin crimson, sap green, burnt umber

TECHNIQUES
- Scraping back

The white of the paper showing through the dry brushwork suggests the crests of the waves.

1 Wet the paper, then paint the cliffs burnt sienna, using the 25mm (1in) flat brush. Use cerulean blue for the distant sky, blending it into the yellow to create a soft green for the distant hills and the areas of shadow on the cliffs.

2 Paint the sea with a wash of cerulean blue, then drybrush turquoise deep (an Old Windsor colour) over the top with the 25mm (1in) flat brush, to strengthen the colour. Carry the turquoise over on to the beach.

BUILDING THE IMAGE

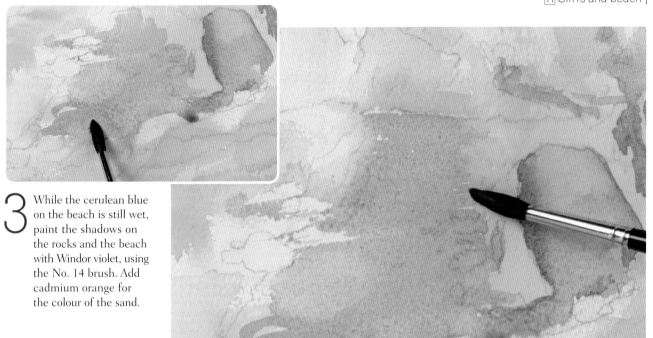

3 While the cerulean blue on the beach is still wet, paint the shadows on the rocks and the beach with Windor violet, using the No. 14 brush. Add cadmium orange for the colour of the sand.

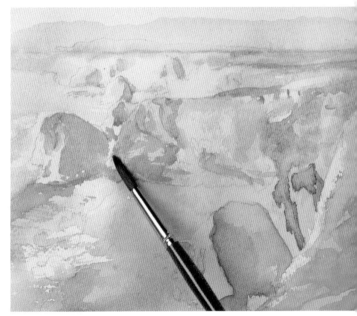

4 Mix cadmium yellow and emerald green and paint the grass, adding cerulean blue for the more distant grass. Add shadows to the rock in the foreground with French ultramarine. Use cerulean blue to paint the distant rock.

5 Strengthen the colour of the sea with turquoise deep, using the No. 5 brush. Paint the mid-range greens on the cliff tops using a lime green mix of emerald green and cadmium yellow, with a little cadmium orange added to it.

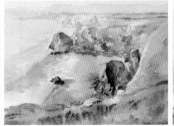
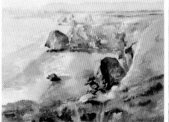
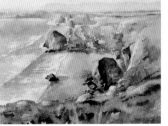

6 Darken the shadows on the rock and paint the pebbles with a mix of burnt sienna and Windsor violet. Paint shadows on the cliffs using the lime green mix with burnt sienna and French ultramarine added to it.

"Keep your painting loose and free."

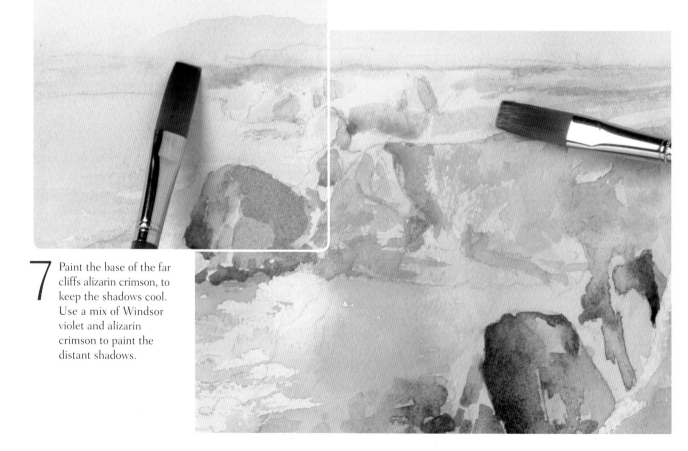

7 Paint the base of the far cliffs alizarin crimson, to keep the shadows cool. Use a mix of Windsor violet and alizarin crimson to paint the distant shadows.

8 Brush the foreground with a clean, wet brush, then paint a mix of sap green and burnt sienna on to the wet paper. While the paint is still wet, add strokes of emerald green and burnt sienna for the grass in the foreground.

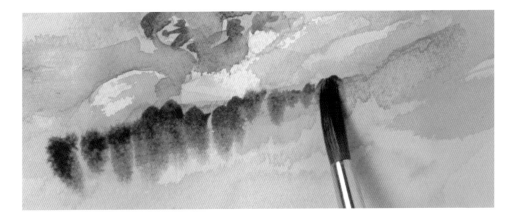

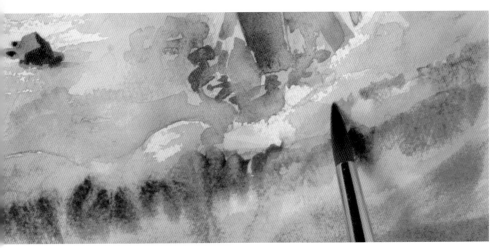

9 Drop clean water on to the foreground to create backrun effects that add interest to the grass. While the paint is still wet, add dashes of alizarin crimson for some local colour.

10 Carry on adding detail, using French ultramarine for the shadows on the grass and burnt sienna on the rocks. Mix sap green and cerulean blue to paint the shadows that help to define the cliffs.

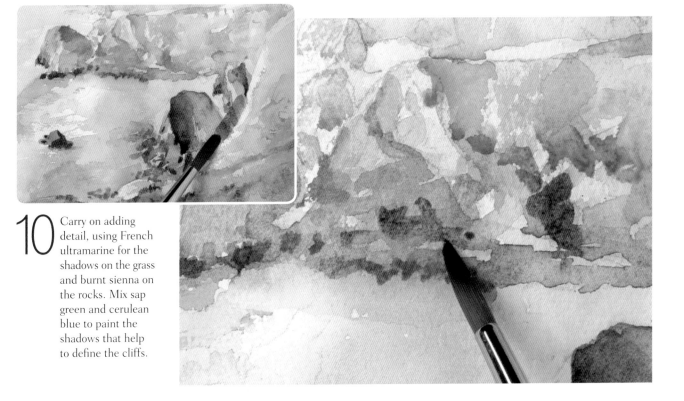

11 Paint the smaller rocks on the beach Windsor violet and add French ultramarine for the shadows. Splatter the foreground with the lime green mix and apply strokes of a mix of burnt umber and sap green for added colour.

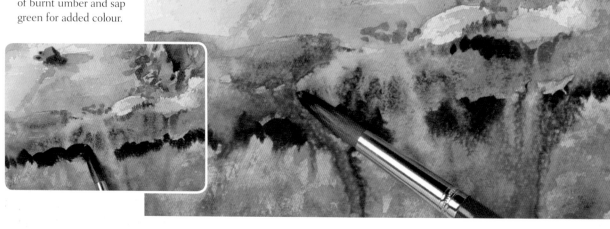

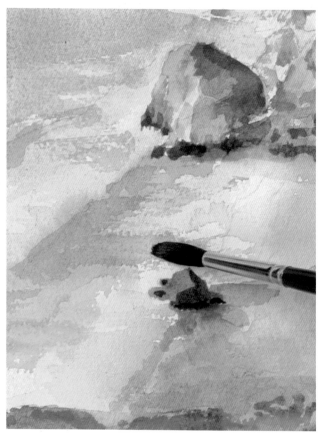

12 Add touches of cadmium orange to the foreground to bring it forward and add cerulean blue to the background to make it recede. Strengthen the colour of the sea with turquoise deep.

13 Add Windsor violet to the far cliffs where they meet the sea to push them back into the distance. Paint the grass on the distant cliffs on the right with a mix of cerulean blue and burnt sienna.

14 When the paint on the sea is completely dry, scrape off some of the paint, using horizontal strokes of a razor blade, to create the effect of the crests of the waves.

SCRAPING BACK

Scratching paint away with a razor blade enables you to create small, broken highlights. Make sure that the razor blade is sharp and only use just enough pressure to scratch away the top layer of paint.

▼ Cliffs and beach

This painting is full of colour and light. The layered washes of colour have created a harmonious interplay of light and shade, and scraping away some of the paint has created sparkling highlights in the sea.

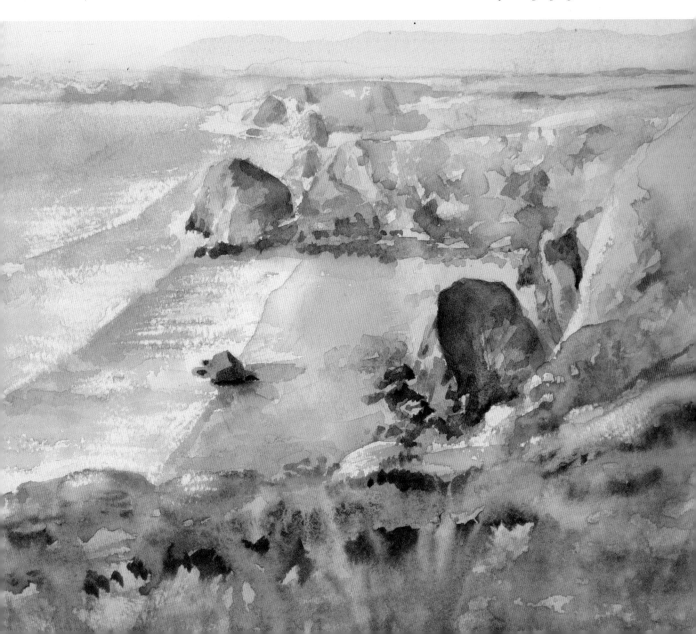

[12] Portrait

Painting portraits may seem challenging, but the techniques you have learnt so far can all help to produce vibrant character studies. The main aim of a portrait is to convey someone's personality through softness, texture, and expression. Delicate skin tones work best when they are built up slowly and layered, wet on dry. This keeps the colours luminous so that they hold the features together as further details are strengthened. The contrast between soft skin tones and strong features helps to create a dramatic, vivid portrayal of your subject's personality.

EQUIPMENT
- Rough paper
- Brushes: No. 5, No. 14, 25mm (1in) flat
- Scalpel or razor blade
- Alizarin crimson, raw sienna, cerulean blue, cadmium red light, burnt sienna, Windsor violet, French ultramarine, cadmium red

TECHNIQUES
- Layering
- Scratching out
- Drybrush

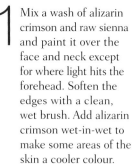

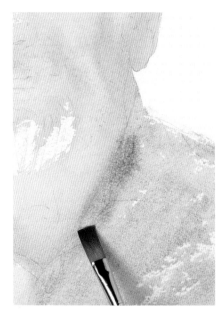

1 Mix a wash of alizarin crimson and raw sienna and paint it over the face and neck except for where light hits the forehead. Soften the edges with a clean, wet brush. Add alizarin crimson wet-in-wet to make some areas of the skin a cooler colour.

2 While the paint on the face is drying, mix a light wash of cerulean blue and paint the shirt. Let the wash break in places, leaving white paper, to create the shirt's texture.

BUILDING THE IMAGE

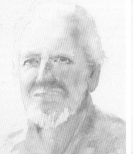
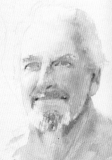

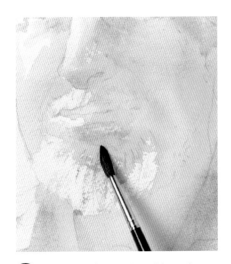

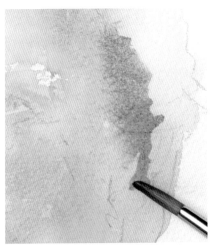

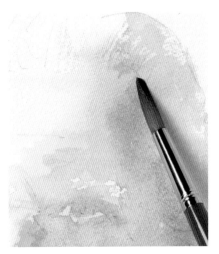

3 When the face is dry, add cerulean blue to the skin mix and use to add shape to the face around the nose. When this layer of paint is dry, add a little alizarin crimson to the centre of the face to bring it forward.

4 Mix alizarin crimson and cerulean blue to make a deep lilac pink and paint the shaded areas at the sides of the face. Paint the shadows around the nose with a mix of raw sienna and cerulean blue.

5 Add raw sienna to the centre of the face, to add warmth. Use a light wash of cerulean blue to paint the hair on the right-hand side of the face and add touches of neat alizarin crimson to the temples.

"Keeping colours separate by letting them dry and layering them makes the colours brighter."

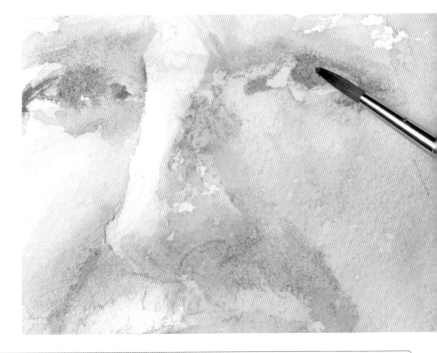

6 Paint cadmium red light around the eyes to define them. Drybrush the same colour down the nose to give it texture – the cadmium red will make the alizarin crimson look cooler. Use pure cerulean blue to paint the eyes.

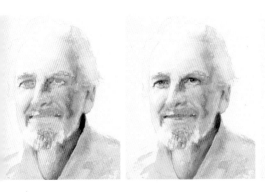

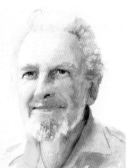

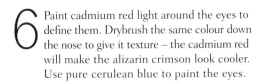

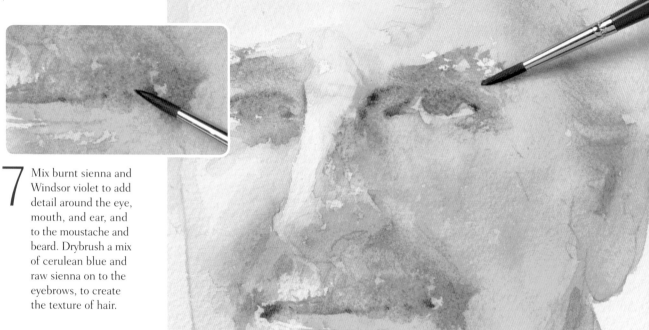

7 Mix burnt sienna and Windsor violet to add detail around the eye, mouth, and ear, and to the moustache and beard. Drybrush a mix of cerulean blue and raw sienna on to the eyebrows, to create the texture of hair.

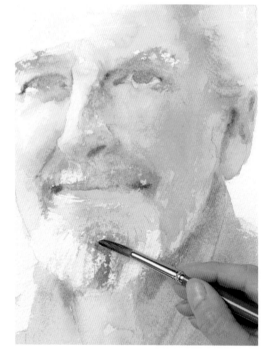

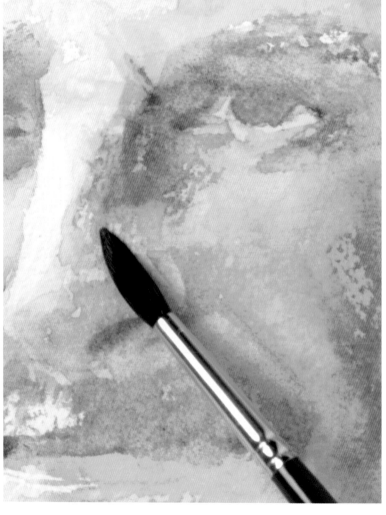

8 Mix burnt sienna and cadmium red together to paint the side of the face. Add French ultramarine and paint the dark areas of the moustache and beard. Use burnt sienna and Windsor violet for the shadow inside the shirt.

9 Model the cheeks and eye sockets with a mix of cadmium red, alizarin crimson, and cerulean blue. Drybrush a mix of burnt sienna and cadmium red on to the right side of the face to create the texture of older skin.

SKIN TONES

Hold a black pencil against the picture to check that the skin tones are dark enough, as it is not always easy to judge when painting on white paper. This will help you to decide whether you need to make any of the colours stronger and darker.

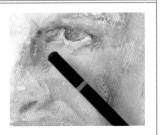

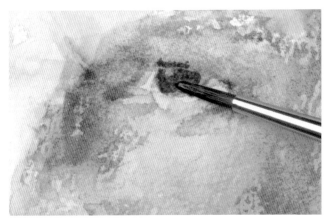

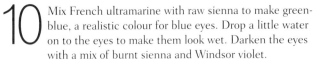

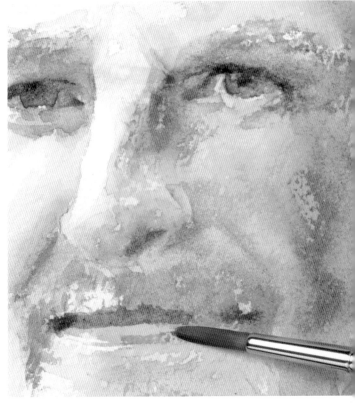

10 Mix French ultramarine with raw sienna to make green-blue, a realistic colour for blue eyes. Drop a little water on to the eyes to make them look wet. Darken the eyes with a mix of burnt sienna and Windsor violet.

11 Strengthen the colour around the eyes with a mix of cadmium red and burnt sienna, then darken the mouth with alizarin crimson. Mix French ultramarine and burnt sienna together to paint the pupils.

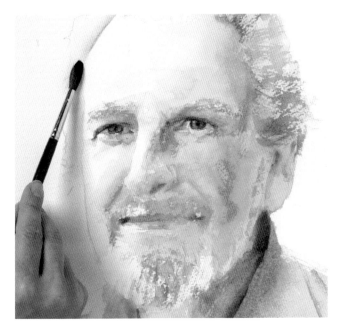

12 Darken the shirt with cerulean blue and burnt sienna. Drybrush details on to the hair with a mix of French ultramarine, burnt sienna, and cerulean blue. Add more details with alizarin crimson and Windsor violet.

13 Add cadmium red to the end of the nose. Use a mix of burnt sienna and French ultramarine for the nostril, the corners of the mouth, and inside the ear, then soften the details with a clean, wet brush.

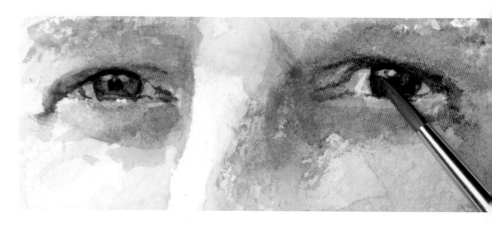

14 Add detail to the moustache with a mix of French ultramarine and burnt sienna, drybrushing it on to add texture. Lift out a little colour on the eyes with a brush. This will create soft, shiny highlights and will make the eyes look glassy.

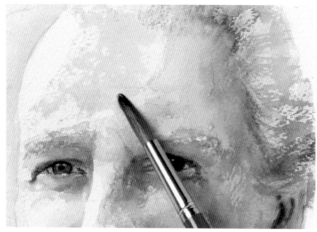

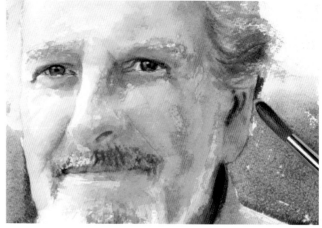

15 Paint alizarin crimson in the centre of the forehead. Drybrush a mix of cerulean blue and burnt sienna on to the hair on the right side of the face to darken it.

16 Paint a background wash of cerulean blue and burnt sienna, graded so it has just a touch of burnt sienna at the top. Lighten the beard by lifting out lines of colour.

17 Use a razor blade to scratch out short, fine lines of paint on the eyebrows. This will take you right back to the paper and create a broken line, which is very good for describing hair. Do the same thing to create highlights in the hair.

Portrait ▶

The slow build-up of skin tones with layers of washes has ensured that the colours have remained fresh. Painting the large, broad shapes of the subject before adding the small details makes the features look more realistic.

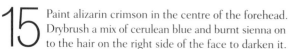

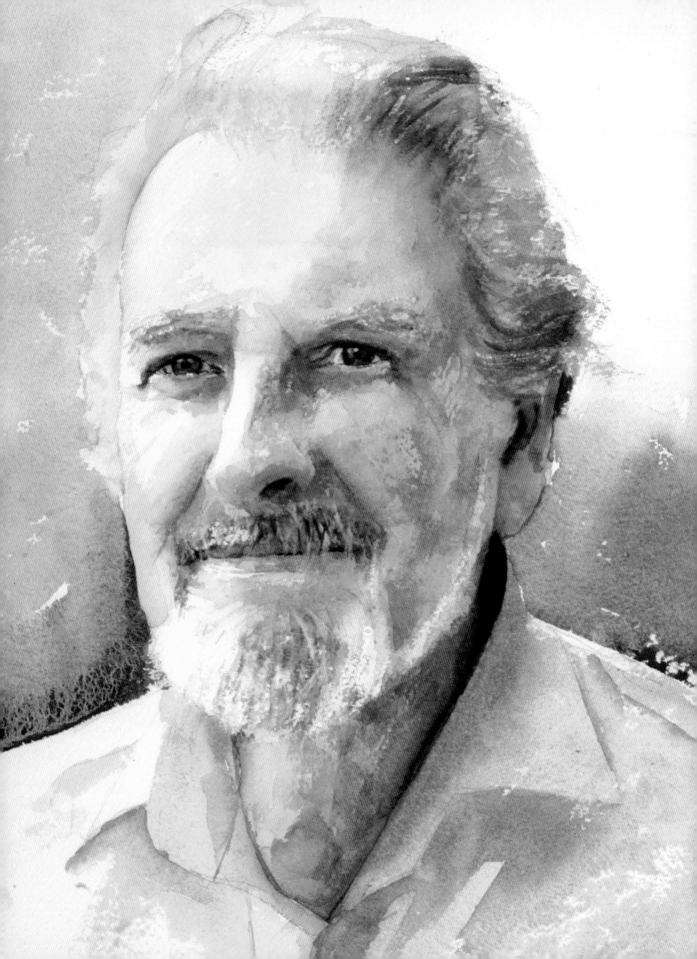

Glossary

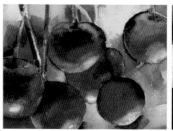

Artists' colours
The highest quality watercolour paints, these contain more fine pigment than students' colours, so produce the most permanent results. They are also more transparent, which means they create more luminous paintings.

Backruns
Irregular shapes, sometimes called blooms, caused when paint in one colour flows into another colour that hasn't fully dried. The marks produced have dark outer edges.

Broken wash
A wash produced by letting a loaded brush glance over the top of the paper as it is drawn across it, so that areas of white paper show through.

Cold-pressed paper
Paper with a slightly textured surface that has been pressed by cold rather than hot rollers during its manufacture. It is sometimes called NOT paper.

Colour mix
Paint that has completely dissolved in water to make a pool of colour.

Colour wheel
A visual device for showing the relationship between primary, secondary, and intermediate colours.

Complementary colours
Colours that are located directly opposite each other on the colour wheel. The complementary of any secondary colour is the primary colour that it does not contain. Green, for example, is mixed from blue and yellow so its complementary is red.

Composition
The design of a painting, which takes into account the main areas of focus and the balance of interest.

Cool colours
Colours with a bluish tone. Cool colours appear to recede in a painting, so can be used to help create perspective.

Dry brushwork
Loading a brush with very little paint and dragging it over the dry paper's surface to produce broken marks. The method is useful for creating texture.

Feathering
Painting lines with water then adding strokes of colour over the top at an angle. The strokes of colour are softened as the paint bleeds along the water lines.

Flat wash
A wash produced by painting overlapping bands of the same colour so that a smooth layer of uniform colour is produced.

Focal point
The main area of interest in a composition. In paintings it is the place where the lightest and darkest marks meet.

Format
The shape of the paper. Commonly used formats are landscape, portrait, and square.

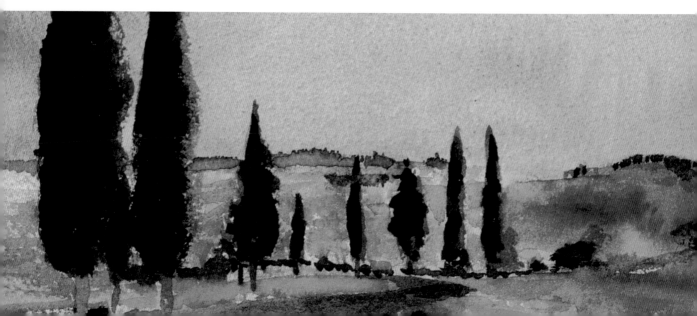

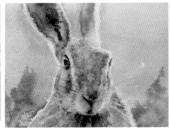 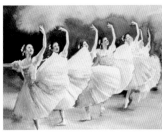 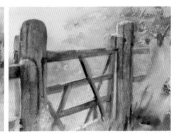

Glazing

Painting one transparent colour over another that has been allowed to dry completely. The first colour shows through the second to create a new colour.

Graded wash

A wash laid down in bands that are progressively diluted or strengthened so that the wash is graded smoothly from dark to light or from light to dark.

Granulation

The separation of paints when they are mixed together in a palette or on paper that occurs if the pigments they contain are of different weights. The resulting granulated mix is speckled and pitted.

Hake brush

A flat wooden brush with goats' hair bristles. Hake brushes are good for painting washes and covering large areas of paper quickly.

Hot-pressed paper

Paper with a very smooth surface that has been pressed between hot rollers.

Intermediate colours

The colours that appear between the primary and secondary colours on a colour wheel. Intermediate colours are made by mixing primary colours and secondary colours together.

Landscape format

Paper that is rectangular in shape and is wider than it is high. It was traditionally used for painting large-scale landscapes.

Layering

Painting one colour over another colour that has been allowed to dry. Unlike with glazing, the colours used can be dark and opaque, so that the under layer of paint does not show through the layer of paint that covers it.

Lifting out

Removing paint from the surface of the paper after it has dried, often to create soft highlights. This is usually done with a stiff, wet brush.

Luminous paintings

Paintings that take advantage of the natural transparency of watercolours, which lets the white paper shine through the paint.

Masking fluid

A latex fluid that is painted on to paper and resists any watercolour paint put over it. Once the paint is dry, the masking fluid can be rubbed away to reveal the paper or layer of paint it covered.

Neutrals

Colours produced by mixing two complementary colours in equal proportions. By varying the proportions of the complementary colours, a range of semi-neutral greys and browns, which are more luminous than ready-made greys and browns, can be created.

 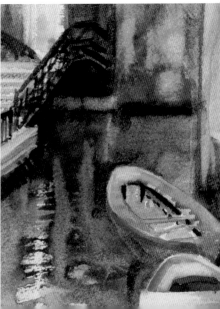

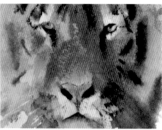
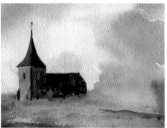

Opaque paints
Dense, non-transparent paints that obscure the colours they are painted over. When opaque paints are mixed together, the results are dull.

Palette
A mixing area for paint, usually with segmented wells to keep different colours separate.

Pan
A small block of solid, semi-moist paint, which comes in a plastic box that can be slotted into a paint box. Paints are also available in half-pans, so a wider selection of colours can be fitted into a paint box.

Perspective
The method of creating a sense of depth on a flat surface. Perspective can be created in a painting by using warm, strong colours in the foreground, and cool, pale colours in the distance.

Portrait format
Paper in the shape of a rectangle that is taller than it is wide. It was traditionally used for standing portraits.

Primary colours
The three colours that cannot be mixed together from other colours: red, yellow, and blue. Any two of these colours can be mixed together to make a secondary colour.

Resist
A method of preserving highlights on white paper or a particular colour by applying a material that repels paint. Materials that can be used as resists include masking fluid, masking tape, and wax.

Rough paper
Paper with a highly textured surface that has been left to dry naturally, without pressing.

Rule of thirds
An aid to composition, which divides a picture into thirds horizontally and vertically to make a grid of nine squares. Points of interest are placed on the "third" lines and the focal point is positioned where two lines intersect.

Sable
Sable fur is used in the finest quality paint brushes. The long, dark brown hairs have a great capacity for holding paint and create a fine point.

Scraping back
Using a sharp blade to remove layers of dry paint in order to reveal the white paper below and create highlights.

Secondary colours
Colours made by mixing two primary colours together. The secondary colours are green (mixed from blue and yellow), orange (mixed from red and yellow), and purple (mixed from blue and red).

Sizing
Sealing a paper's fibres with glue to prevent paint from soaking into the paper. Blotting paper is un-sized and therefore very absorbent.

Softening
Blending the edges of a paint stroke with a brush loaded with

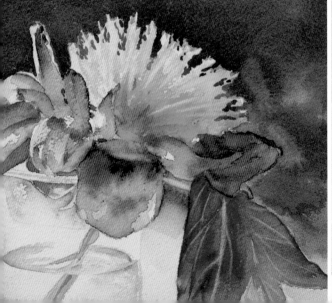

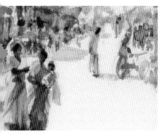

clean water to prevent paint from drying with a hard edge.

Splattering
Flicking paint from a loaded paintbrush on to a picture to produce blots and patterns useful for texture.

Sponging
Pressing a sponge dipped in paint on to paper to create a mottled mark that is good for creating texture.

Squirrel brush
A very soft brush made from squirrel hair. Squirrel brushes do not hold much paint but are good for softening and blending colours.

Strengthening
Building up layers of paint to make colours stronger. This is frequently done because paint colours become paler when they dry.

Stretching
The method of wetting paper with a damp sponge, taping it to a board, and letting it dry flat. Stretching paper helps to prevent the paper buckling when you paint on it.

Students' colours
A cheaper range of paints than Artists' colours. Student's colours do not contain the same high level of pigments as Artists' colours and therefore do not produce such good results.

Toned paper
Paper that has a coloured surface. White paint has to be added to coloured paints to make the lightest tones on such paper.

Tone
The relative lightness or darkness of a colour. The tone of a colour can be altered by diluting it with water or mixing it with a darker pigment.

Viewfinder
A framing device that can be used to show how a subject will look in a variety of compositions before painting. A simple viewfinder can be made by cutting a rectangular hole in a piece of cardboard.

Warm colours
Colours with a reddish or orange tone. Warm colours appear to come forward in a painting and can be used to help create a sense of depth.

Wax resist
Method of using candle wax to prevent the surface of the paper from accepting paint. Once applied, the wax cannot be removed.

Wet-in-wet
Adding layers of colour on to wet paper or paint that is still wet. This method makes it possible to build up paintings quickly with soft colours, but it is less predictable than painting over paint that has already dried.

Wet on dry
Adding layers of paint on top of colour that has already dried. Painting in this way produces vivid colours with strong edges, so the method can be used to build up a painting with a high level of accuracy.

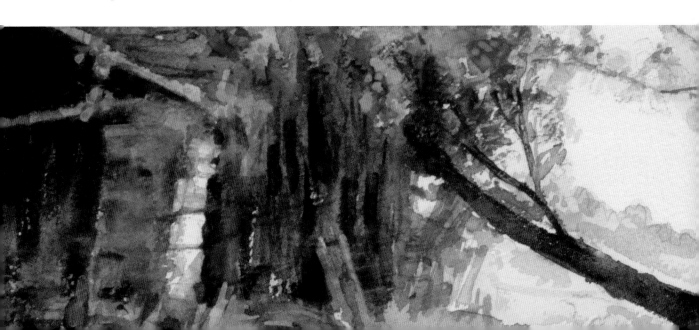

Index

Acknowledgements

PUBLISHER'S ACKNOWLEDGEMENTS

Dorling Kindersley would like to thank: Murdo Culver, Mandy Earey, Katie Eke, Karla Jennings, Simon Murrell, Lee Riches, and Rachael Smith for design help; Caroline Hunt for proofreading; Dorothy Frame for compiling the index; Lesley Grayson for picture research; Simon Daley for jacket series style; Ian Garlick for jacket photography; Sharon Spencer for jacket design; Amber Tokeley for jacket editing; Monica Pal for administrative support.

PICTURE CREDITS

Key: t=top, b=bottom, l=left, r=right, c=centre

p.43: © Robert McIntosh/CORBIS (tr); *p.60:* © The Art Archive/British Museum/ Eileen Tweedy (bl); *p.61:* © Philadelphia Museum of Art/CORBIS (c); *p.80:* © The Art Archive/Private Collection London (b); *p.100:* Phyllis McDowell (t); *p.102:* © The Art Archive/Victoria and Albert Museum London/ Sally Chappell (t); *p.103:* © Brooklyn Museum of Art/CORBIS (t).

All jacket images © Dorling Kindersley.